First published in the United States in 2009 by Chronicle Books LLC.

Library of Congress Cataloging-in-Publication Data available.

ISBN: 978-0-8118-6640-8

Manufactured in China.

Cover design: Brad Mead
Art director: Jane Waterhouse
Design concept: Jane Waterhouse
Design and layout: Lisa Båtsvik-Miller
Editor: Lindy Dunlop

Published and distributed outside of North America by RotoVision SA.
Route Suisse 9
CH-1295 Mies
Switzerland

10 9 8 7 6 5 4 3

Chronicle Books LLC
680 Second Street
San Francisco, CA 94107

www.chroniclebooks.com

about the author

An accomplished and recognized Lomographer, Kevin Meredith was ranked
second in the world at the Lomolympics 2000 in Tokyo, and was awarded
third place at the Lomographic World Congress in Vienna in 2002. His
commissions include photography for Dr. Martens; the Manchester
Commonwealth Games; and The National Gallery, Victoria and Albert
Museum, and Royal College of Art, all in London. His work has been
published in two Lomo photographic books: *Spirit* and *Don't Think Just
Shoot*, and he was on the judge's panel for flickr.com's The Blink of an
Eye photo contest and New York exhibition in 2006.

Contents

Foreword

Heather Champ and Derek Powazek, founders of *JPG* magazine

Heather: My admiration of Kevin's work began with his iconic photograph of Imogen Heap, garbed in scarlet, riding a bicycle down a London road (page 045). That photo exemplifies the feeling of joy that runs through all of Kevin's photography. Later, when Derek and I created *JPG* magazine, he was at the top of our list of people we wanted to feature. Admiring someone's work from afar is one thing, but interacting with them is quite another, and let's face it, photographers can be difficult. Luckily, Kevin's not that guy—not even remotely.

Derek: Kevin is excited about photography, and it's catching. Seeing his work sent me to garage sales and websites, looking for old, imperfect gear. But his excitement stems from being part of the world, not hiding from it behind a camera. Good thing too, because he's not exactly unnoticeable in person. In the time I've known him, he's swung from looking like a straightedge punk to Fidel Castro and back. His excitement is what draws his subjects to him, as well as other photographers.

Heather: If you've ever been shooting with Kevin, you'll know that there's a moment when he empties a never-ending series of pockets and a pile of small, well-worn cameras appears before you. "That's it?" you wonder. "Where's the expensive, aggressive, and manly camera equipment? Where are the 6ft lenses and the attitude?" That's the genius of Kevin Meredith. He's teasing his view of the world from small chunks of metal and glass.

Derek: Watching Kevin's photo output, even the most experienced photographer will eventually wonder, "How does he do that?" This book is a rare first-person glimpse into Kevin's instinctive technique. But, more importantly, it's an example of a photographic methodology that is more about the moment than the camera.

Introduction

I have written this book to make it easy for you to dip in and out of. As you flick through, you can stop at any photograph to find out how it was shot—you don't want to be sitting indoors reading a book when you could be out taking photos! But there are a few fundamental concepts that you must understand in order to delve deeper into photography. These are:

• composition and the rule of thirds (page 180);
• exposure (page 182);
• shutter speed (page 184);
• aperture and depth of field (page 186); and
• types of camera (pages 188–194).

Though Photoshop is not a large part of my photography, I do use it for a few basic tasks, and for that reason I've included a small section on Photoshop essentials at the back of this book (pages 202–209).

It is important to know when a shot was taken so that you can get an idea of the light involved, so I have given the lighting conditions for every shot. This will give you a better understanding of the effect of different lighting conditions, and how this will affect your photo. Most of the shots in this book were taken outside with only the light from the sun.

Category index

 Abstract

 Color

 Action

 Composition

 Animals

 Depth of field (DOF)

 Architecture/buildings

 Filters

 People

 Exposure

 Perspective

 Graphic

 Silhouette

 Landscape

 Still life

 Low light

 Vignetting

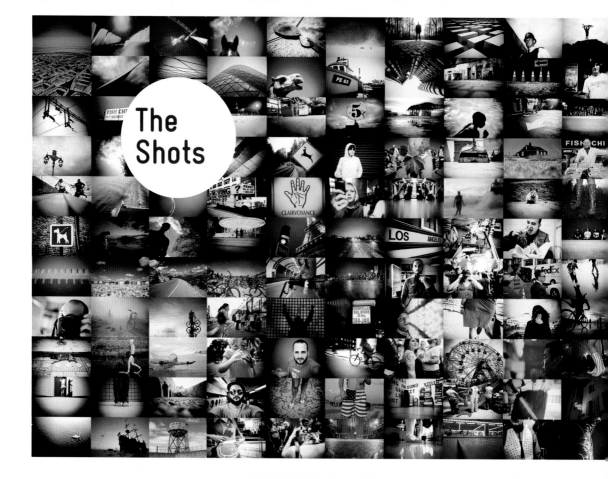

The
Shots

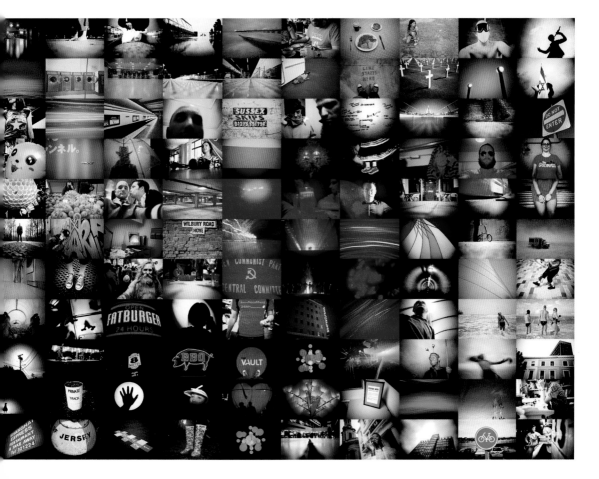

Faceless portrait

Portraits don't have to include the subject's face: you can focus on any part of the body you wish. What makes this composition is the stark contrast between the patterns of the subject's polka dot dress and fishnet stockings, and the simple background of soft horizontal lines formed by the bench. Color is also important, as the red of the dress contrasts strongly with the subtle tones of her skin and the bench. Including a really strong color in an image to make it more eye-catching is a technique known as the Red Shirt School of Photography.

Camera: Lomo LC-A [ZF]
Lens: 32mm
Focal length: 32mm
Film: Agfa Precisa 100, transparency, cross-processed
Shutter speed: N/A
Aperture: auto
Accessories: none
Light: early morning, overcast, rainy

↗ This technique was popularized by National Geographic photographers in the 1950s. The color needn't be red, but red generally has a stronger impact than other colors. You can see this effect at work on pages 009 and 045.

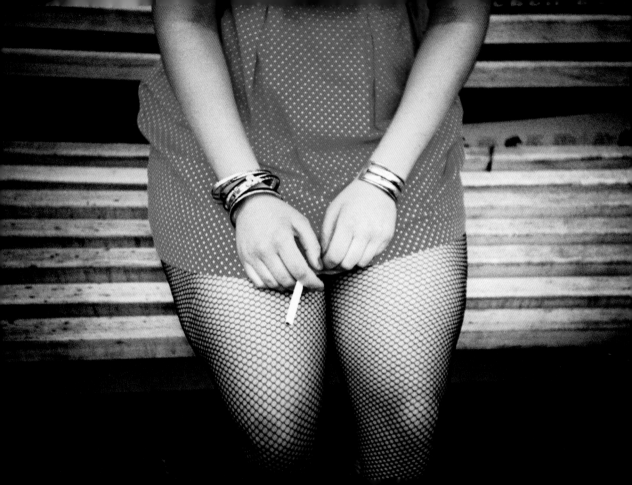

Super color contrast

This shot was achieved using nothing more than colored gel. I placed a red gel over the flash so that when it fired, the light from the flash took on the color of the gel. The background isn't red because the light from a flash only has an effect over a certain range, and the wall behind the subject was too far away for the flash to have an effect on it. The back wall appears blue because, in most cases, artificial indoor light will give a color cast—usually blue, green, or yellow—unless you have expensive daylight bulbs. If this had been the case, the real color of the wall—white—would have been captured.

Camera: Lomo LC-A [ZF]
Lens: 32mm
Focal length: 32mm
Film: Fujicolor Superia Reala 100, negative
Shutter speed: N/A
Aperture: auto
Accessories: flash with red gel
Light: artificial indoor

↗ *A color cast is usually undesirable, but you can turn it to your advantage. If you use a digital camera you need to turn off the auto white balance or the camera will try to make the background color appear as though it has white light shining on it.*

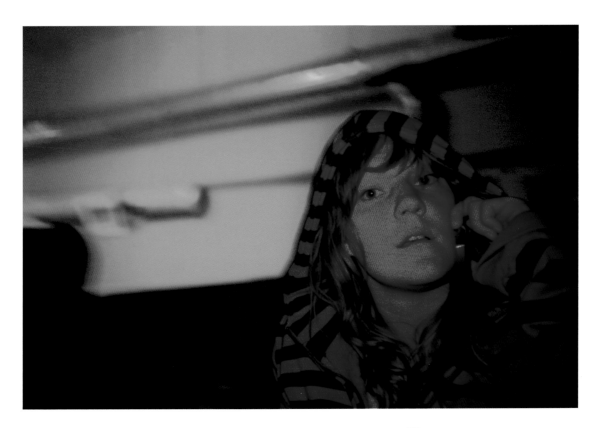

Soft focus

The dreamy effect of this shot is created by what is called soft focus.
It's not that the photo is out of focus, rather that the contrast and edges
in the photo are softened. In this case the softening was caused by sea
spray on the lens distorting the image. A very cheap method that some
photographers use is to smear a little Vaseline on the lens, but I wouldn't
advise this: most lenses have a chemical coating that can be damaged
by contact with other chemicals. It would be better to apply Vaseline to
an ultraviolet filter and attach that to your lens; it would also be easier
to clean the filter afterward.

Camera: Nikonos-V [NiV]
Lens: 35mm
Focal length: 35mm
Film: Fuji Superia 400, negative
Shutter speed: N/A
Aperture: N/A
Accessories: soft-focus filter
Light: early morning, clear sky

↗ This photo was taken with a waterproof camera so I knew the sea spray wouldn't cause
any damage, but there are many environments that are not friendly to cameras, so it's
always a good idea to carry a lens cloth to give your kit a good rubdown afterward.

Off-center focus

If you are using a camera with autofocus you need to be mindful of what you are focusing on because many autofocus cameras try to focus on the center of the frame. For this image that would have resulted in the grass in the background being in focus and the legs in the foreground being blurry. Most autofocus cameras have a two-stage shutter button. This means you can press and hold the shutter button halfway down to focus on what you have in the center of the frame, then recompose the shot before depressing it fully. I used this facility to keep the legs in focus. A bonus is that it cuts down on shutter lag—the delay between when you press the shutter button and when the picture is taken. This is simply the time it takes the camera to focus and set exposure levels.

Camera: Contax T2 [CAF]
Lens: 38mm
Focal length: 38mm
Film: Agfa Ultra 100, negative
Shutter speed: N/A
Aperture: N/A
Accessories: none
Light: early morning, bright sunlight

↗ When choosing a new digital camera, one of the most important things to look at is shutter lag. With older models this can range from 0.1 to 1.5 seconds. This may not sound like a lot, but it can make all the difference to your shot.

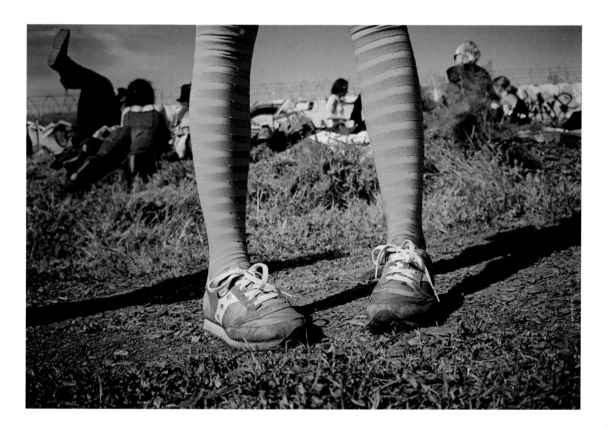

Short-range focus

With the old-style, non-autofocus cameras I use, it's not the easiest thing to get your subject in focus at short range. You have to set the focus distance to the distance the subject is from you, but you can't tell what is in focus by looking though the viewfinder because the lens you are looking through is not the same lens that the photo will be taken through. I carry a small tape measure, customized with marks at 80cm and 1.5m (c. 2ft 8in and 5ft), as these are the Lomo LC-A's smallest increments of focus. This means I can quickly measure the distance to get super-sharp close-up shots. For this job, I knew I would be needing to measure all the time, so I simply carried a piece of wood cut down to 80cm (c. 2ft 8in).

Camera: Lomo LC-A [ZF]
Lens: 32mm
Focal length: 32mm
Film: Agfa Precisa 100, transparency,
 cross-processed
Shutter speed: N/A
Aperture: auto
Accessories: tape measure
Light: morning, bright sun in the shade

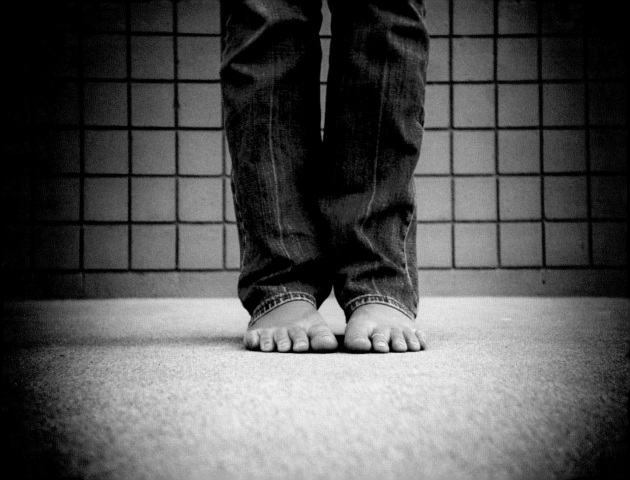

Graphic composition

Sometimes the simplest things are the best. Rather than shooting so that the hopscotch field ran horizontally from left to right, I shot it at an angle so that it fills more of the frame, and gives a better sense of perspective. When composing the shot, I also made sure there were no objects or people in the frame, because they would have detracted from the bold, simplistic nature of the image. You can quite often make really strong graphic compositions by shooting street signs and road markings. Most of the time I use cross-processing for this type of shot because it makes the colors far more striking against the dark ground.

Camera: Lomo LC-A [ZF]
Lens: 32mm
Focal length: 32mm
Film: Agfa Precisa 100, transparency,
 cross-processed
Shutter speed: N/A
Aperture: auto
Accessories: none
Light: afternoon, overcast

↗ This shot was taken one rainy, overcast day. If it had been taken on a bright, sunny day, the contrast would have been a lot higher and the color tone would not have been as subtle. You can see how this type of shot turns out in bright sun on page 035.

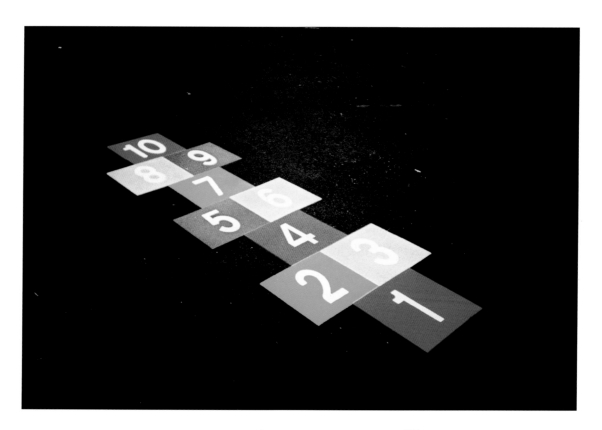

Arm's-length self-portrait

You don't need a cable release and tripod to take a self-portrait, just an outstretched hand. To avoid getting your arms in the picture try to tilt the camera slightly upward and away from your arms. I took this early on a winter morning, when there is never much light about, so I was shooting on 1600 black-and-white film, which is why the picture is so grainy. The higher the ISO rating of the film, the faster it is, and the faster the film, the better it can cope with low-light conditions.

Camera: Nikonos-V [NiV]
Lens: 35mm
Focal length: 35mm
Film: Fuji Neopan 1600 Professional, negative
Shutter speed: N/A
Aperture: N/A
Accessories: none
Light: early morning, winter, overcast

↗ If you like high saturation in color photography, don't use color film with a rating of over 400—the colors become a lot less saturated with ratings higher than this.

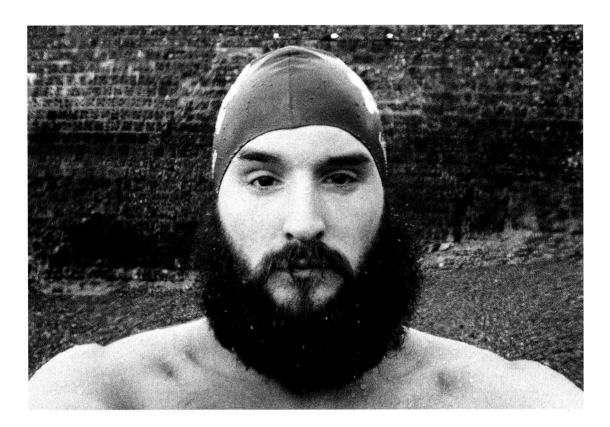

Narrow depth of field

I have used selective focus in this shot, choosing to focus on Mary's camera. With the Lomo LC-A you don't get much control over aperture, and therefore over depth of field. As the conditions were dull, and I was using a slow film (100 ISO), I knew the aperture would be wide open, giving a narrow depth of field, which meant that what I specifically focused on would be in focus, but not much else. As my camera had no autofocus, I set its focus distance to 80cm (c. 2ft 8in), then measured the distance to Mary's camera by pointing at it with my outstretched arm and touching her camera with the tip of my finger. (I know my arm is roughly 80cm long).

Camera: Lomo LC-A [ZF]
Lens: 32mm
Focal length: 32mm
Film: Agfa Precisa 100, transparency, cross-processed
Shutter speed: N/A
Aperture: auto
Accessories: none
Light: afternoon, overcast

↗ Photographs aren't always all about composition; sometimes they're about the story behind the image. Having all the figures on the left out of focus makes viewers curious; it engages viewers, prompting them to think about what is going on in the shot.

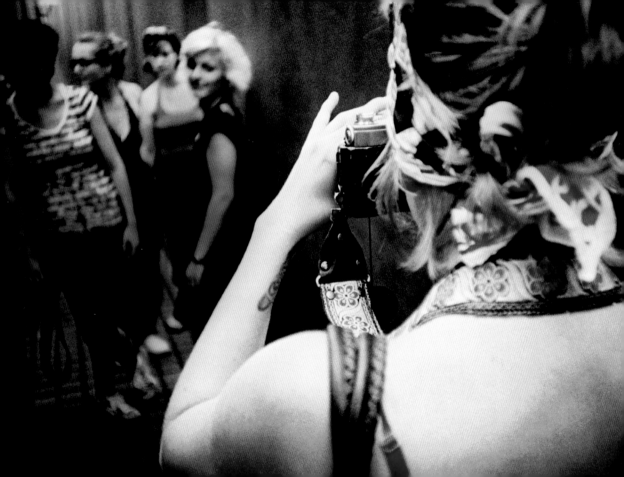

Subject's point of view

I like to shoot photos from the same point of view as the subject to give the viewer a sense of what it's like to be there with them. This shot was taken from the point of view of another swimmer. Swimming along with the subject was hard work: holding a camera meant I couldn't use my arms, but I did have fins on so I was able to keep up. I was shooting on 400 ISO film so I could close the aperture down to give me a large depth of field. I set the camera to aperture priority to give me a better chance of getting the subject in focus—it was hard to maintain a constant distance between us. I could have taken the shot from a boat, but the image would have felt disconnected from the subject.

Camera: Nikonos-V [NiV]
Lens: 35mm
Focal length: 35mm
Film: Fuji Superia 400, negative
Shutter speed: N/A
Aperture: N/A
Accessories: none
Light: morning, bright sun

↗ *What makes this composition is the contrast between the swimmer's modern-looking cap and goggles and the traditional rigging of the sailing ship. A difference between colors or light and dark needn't be the only source of contrast in a shot.*

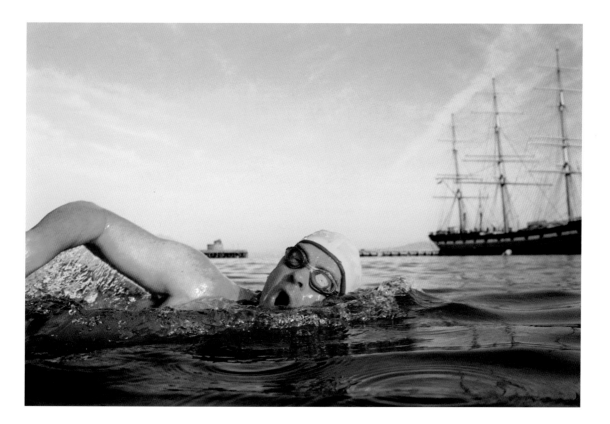

Negative space

This was shot on the deck of a ferry very early on a sunny, warm morning. I love taking photos of sleeping people because it guarantees a natural photograph—sleeping people don't react to what you are doing. I made use of negative space, the space around and between the subject(s) of an image, to create a stronger composition. For an image to have impact, negative space is just as important as positive space (the subject), so you should always consider it. Rather than having the subject in the middle of the frame, or moving closer to him so that he filled the frame (and risk waking him up), I included a large area of green to create a sense of oddness.

Camera: Contax T2 [CAF]
Lens: 38mm
Focal length: 38mm
Film: Agfa Ultra 100, negative
Shutter speed: N/A
Aperture: N/A
Accessories: none
Light: early morning, bright sun

↗ *In this image color is also important. The colors of the sleeping man's clothes work subtly together—the green shirt, cream trousers, and brown shoes are all quite earthy colors and work well with the green of the deck.*

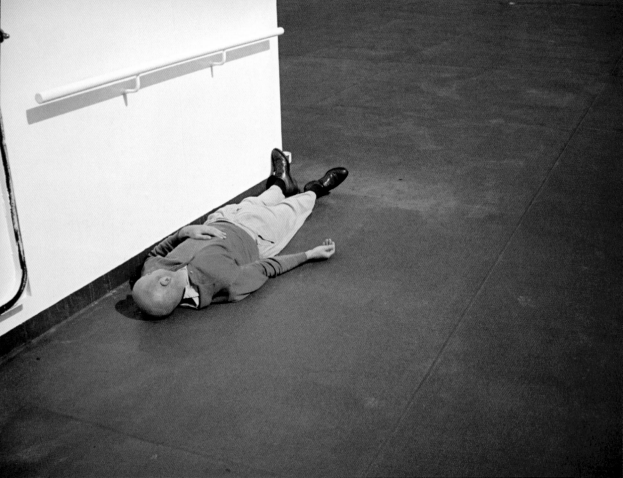

Lens vignetting

This was taken on Brooklyn Bridge in New York. I wanted to achieve a certain level of abstraction, so didn't include any of the bridge's stone towers. It was shot directly into the sun. When I composed the image, I made sure the sun was hidden behind one of the thick horizontal cables in the middle of the shot. The result is a really good, if very extreme example of lens vignetting, graduating from white in the middle to black at the edge. It is caused by more light getting through the middle of the lens than the edge. It's a common result with a low-quality lens, and is normally perceived as undesirable. If I hadn't hidden the sun, the glare would have been very distracting and other effects, such as lens flare, could have ruined the shot.

Camera: Lomo LC-A [ZF]
Lens: 32mm
Focal length: 32mm
Film: Agfa Precisa 100, transparency, cross-processed
Shutter speed: N/A
Aperture: auto
Accessories: none
Light: looking into bright sun

↗ As you can see in the sample shot at right, if I had not covered up the sun, most of the cables would not have been visible. Of course, a glare effect can be desirable in some situations, as in the shot on page 161; after all, photography is an art, not a science.

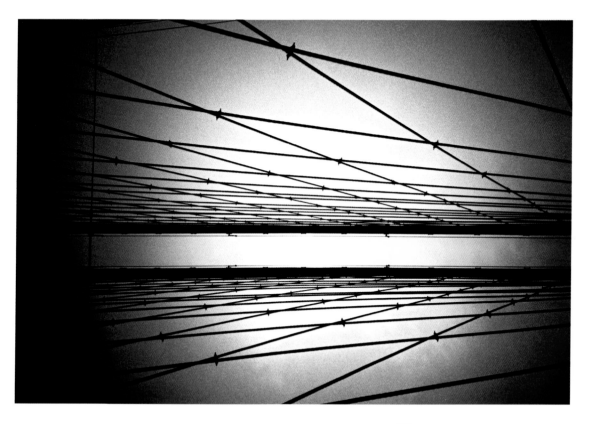

Cut-and-paste

For this shot I wanted cyclists riding into the distance, with one coming past me to give a sense of scale and perspective. I asked the riders to go past as close as they could without hitting me: I knew if they saw me bending down to take the shot they would instinctively give me a wide berth. I set a small aperture to give a large depth of field so that everything from the sand just in front of me to the horizon was in focus, and set a fast shutter speed so that most motion would be frozen. The strongest shot had a bike passing close by, filling one-third of the frame, but the right side felt empty, which left the image unbalanced. Luckily, I had another shot in which this part was filled with a bike. Using Photoshop, I cut this bike out of the one shot and pasted it into the other.

Camera: Canon EOS 5D [DSLR]
Lens: 20–35mm
Focal length: 20mm
ISO: 800
Shutter speed: 1/200 sec
Aperture: f/16
Accessories: none
Light: early morning, sunrise

↗ I focused on the ground at a point where the cyclist would be when I took the shot so there would be no delay with the camera trying to focus when I pressed the shutter button. That way I could capture what I saw as it happened.

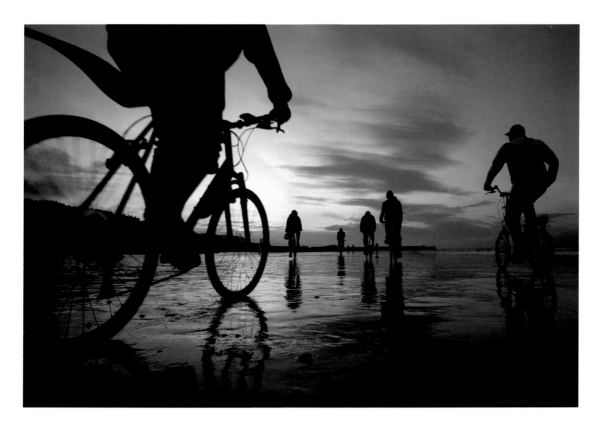

Kinetic photography

To take shots like these you need to set a long exposure and spin on the spot with your camera. To get the circular light patterns I pointed the camera upward and spun; for the horizontal patterns I pointed the camera in front of me and spun. If you are using an SLR, set your camera to manual focus and shutter priority (TV), with an exposure of 5 seconds or more. The best environments for this type of photography, known as kinetic photography, are bars and clubs, because they tend to be dark and have a lot of decorative lighting.

Cameras: Lomo LC-A, Cosina CX-2 [ZF]
Lenses: 32mm, 35mm
Focal lengths: 32mm, 35mm
Films: mixed 100, negative and transparency
Shutter speeds: 4 sec and over
Apertures: auto
Accessories: none
Light: artificial indoor, dark

↗ *For the best effect, take your photos in a dark room with weak lights. If the lights are too bright, the exposure will be too short, and you won't capture much motion.*

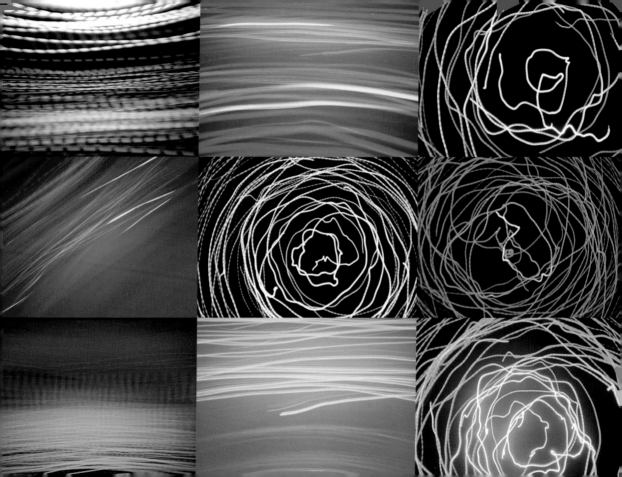

Selective crop

Photography is not all about a single image. When I shot this set I was shooting to get one image, but when I saw the contact sheet, it became obvious I had a set that would work well together. What I was trying to do with these shots was get just the horse and the blue sky. Shooting the horses so I never got their entire heads gives them more character. It makes them seem more cheeky than a "normal" horse. The sky is a lovely deep blue because of the increased contrast created by cross-processing. Shooting with the sun behind me also helped make it deep blue. All of these images were cropped in camera. When you look through the viewfinder, try to imagine what you would crop out, and simply move closer to achieve that.

Camera: Lomo LC-A [ZF]
Lens: 32mm
Focal length: 32mm
Film: Agfa Precisa 100, transparency, cross-processed
Shutter speed: N/A
Aperture: auto
Accessories: none
Light: afternoon

↗ I could have taken a shot of the horse's head in full, then cropped it in Photoshop, but it isn't a good idea to get into the habit of shooting and cropping later because the pixels, or film grain, will be enlarged in the final print, reducing the quality of the image.

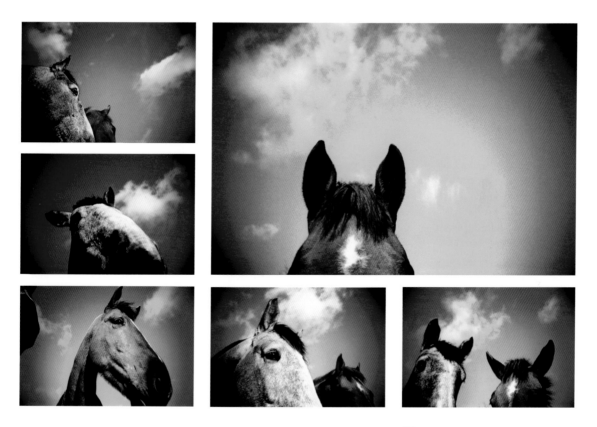

High contrast

This was shot from a pedestrian bridge above a road in Queens, New York. I had to wait a while to get the shot without any cars, but it was worth it. I flipped the image because it made the composition stronger and also set the road marks the right way up to read, but they have been transformed from something mundane and everyday into something more abstract.

Camera: Lomo LC-A [ZF]
Lens: 32mm
Focal length: 32mm
Film: Agfa Precisa 100, transparency,
 cross-processed
Shutter speed: N/A
Aperture: auto
Accessories: none
Light: midday, direct bright sun

↗ This image has a high contrast because it was shot at midday, when the sun was at its highest and brightest. Cross-processing pushed the contrast further, making it black-and-white, with no grays in between. You can see a similar photo of tarmac shot on an overcast day on page 017.

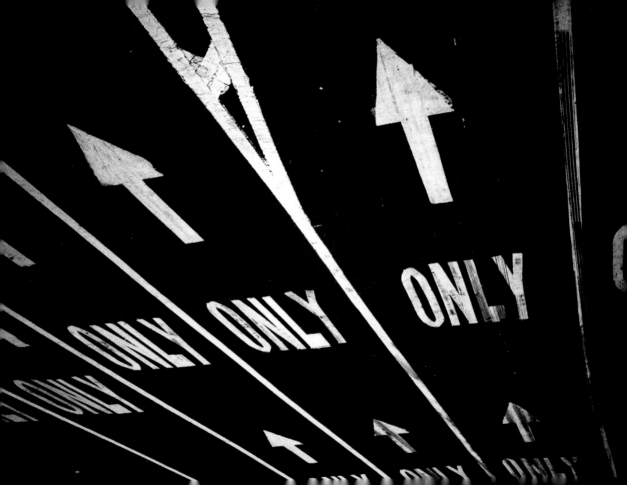

Contrasting background

Backgrounds can make or break an image. I have talked about how you can blur the background with depth of field (see page 186) to make it less distracting, but if you are using a camera that allows you no real control over depth of field, like most compacts, you might want to consider finding a background that contrasts well with your subject. It's harder than you might think to find backgrounds of this caliber. I once worked on a product photography job for which the products—shoes—all had to be shot on backgrounds like this. Most of the shoot was spent driving around in search of backgrounds!

Camera: Nikonos-V (NiV)
Lens: 35mm
Focal length: 35mm
Film: Agfa Ultra 100, negative
Shutter speed: N/A
Aperture: N/A
Accessories: none
Light: late afternoon, sunny

↗ This was shot at the drained McCarren Park Pool in Brooklyn, New York City. Another example of a wonderful textured background is the floor in Amoeba Records in San Francisco (see page 097).

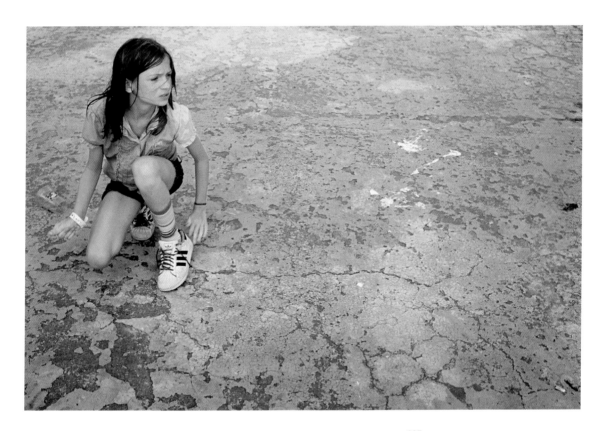

Long exposure

I took this quick snapshot with just the ceiling lights of the elevator to illuminate the scene. Because it was dull, the Lomo took this as a long-exposure shot. (Long exposure generally refers to a shutter speed of over 1/60 sec.) You can tell when a Lomo will take a long exposure because a red light appears in the right of the viewfinder when you press the shutter button halfway down. For a long exposure you must make sure the camera stays still while you take the shot. For this photo I steadied myself against the wall of the elevator because there wasn't enough time to set up a tripod. When taking long-exposure shots like this, you must press and hold the shutter button until you hear the second click—this is the sound of the shutter closing after a long exposure.

Camera: Lomo LC-A [ZF]
Lens: 32mm
Focal length: 32mm
Film: Kodak Elite Chrome 100, transparency
Shutter speed: N/A
Aperture: auto
Accessories: none
Light: artificial indoor

↗ *Images shot under artificial light (light from a source other than the sun) tend to have a color cast, in this case green. You can see this effect with a different color on page 009.*

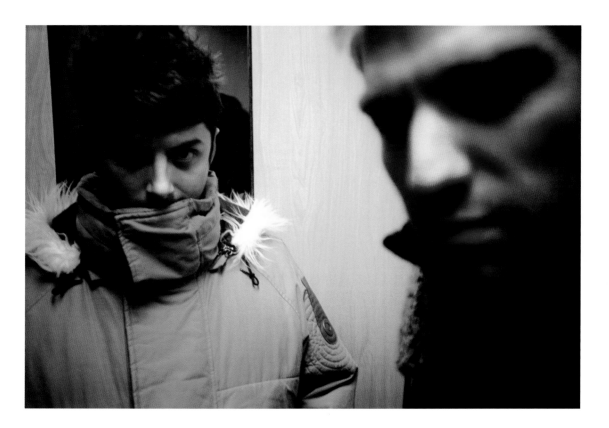

Shooting reflections

For shooting reflections on the ground like this, I like to shoot more of the reflection than the subject, then display the photo upside down. It's a simple way of presenting the viewer with a completely different way of looking at something. This was shot during sunset when the light was warm and golden, which is why the people appear yellow. The color appears more golden than it really was, because it was shot on Agfa Ultra, a high-color-saturation film. Wet surfaces tend to give the best reflections, like wet tarmac or puddles. The smaller image was shot in the early morning. It seemed natural to me to flip it so that it looks as though Janet is holding the world on her shoulders.

Camera: Contax T2 [CAF]
Lens: 38mm
Focal length: 38mm
Film: Agfa Ultra 100, negative
Shutter speed: N/A
Aperture: auto
Accessories: none
Light: sunset

↗ *When the subject is traveling, moving, or looking in a certain direction, you need to have space in front of them so they aren't looking or traveling into the edge of the frame. That rule is broken here, but the subtle sense of perspective, created by the stones on the sand, helps to lead the viewer's eye behind the walkers.*

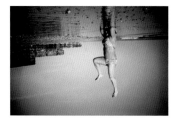

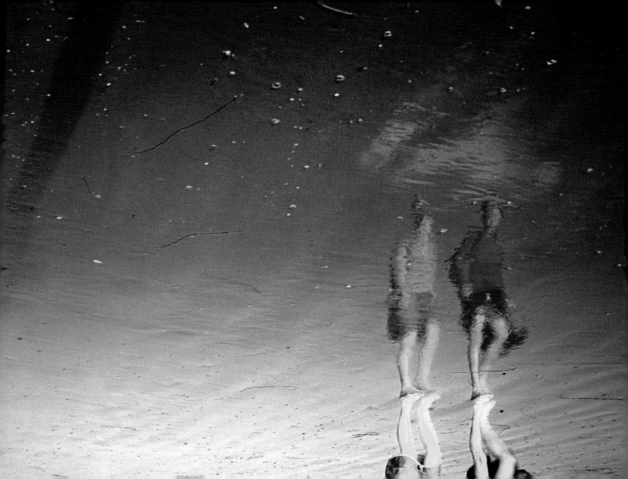

Vanishing points

I took this shot by placing the camera on the textured yellow tiles that line the station platform. The image relies on a vanishing point to give a sense of scale. If you have a camera with autofocus, make sure you set the focus to manual and focus on infinity, otherwise the camera might try to focus on the ground directly in front of it, and the distant part of the shot will be out of focus. This image shows that you don't always have to stick to the rule of thirds (see page 180), as the vanishing point is in the middle of the frame. To make the yellow stand out I increased the saturation using the Variations palette in Photoshop. (See Color correction, page 202.)

Camera: Lomo LC-A [ZF]
Lens: 32mm
Focal length: 32mm
Film: Fuji Superia 400, negative
Shutter speed: N/A
Aperture: auto
Accessories: none
Light: dull, overcast

↗ *The composition in this shot works well because the two strongest shapes (the elongated triangle formed by the yellow floor tiles and the elongated triangle formed by the black roof) balance each other out and lead the eye to the same point.*

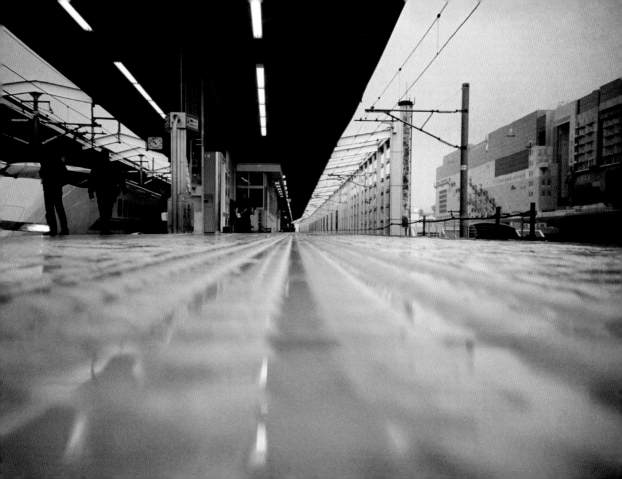

Blurred background

The reason this composition works so well is that the red of Imogen's coat is framed by the white of the building behind her, and also because there's a large amount of space in front, in her direction of travel. This space helps because the viewer's eye is always drawn in the direction an object is "traveling" in a photograph. If the front of the bike was at the edge of the frame, the viewer's eyes would be led out of the photo, which is just what you don't want. Another thing that makes this image work so well is that the bike and Imogen are sharp, but the background is blurred. This is called motion blur, and it occurred because we were both cycling; relative to Imogen and me, only the buildings were moving. This effect works best with shutter speeds of 1/60 sec and slower.

Camera: Lomo LC-A [ZF]
Lens: 32mm
Focal length: 32mm
Film: Agfa Precisa 100, transparency, cross-processed
Shutter speed: N/A
Aperture: auto
Accessories: none
Light: overcast

↗ You don't have to be moving with the subject to get motion blur. You can set your camera to a slow shutter speed and pan with the subject as it passes you. Frame your subject and move your camera to keep it in the same position within the frame while you keep still.

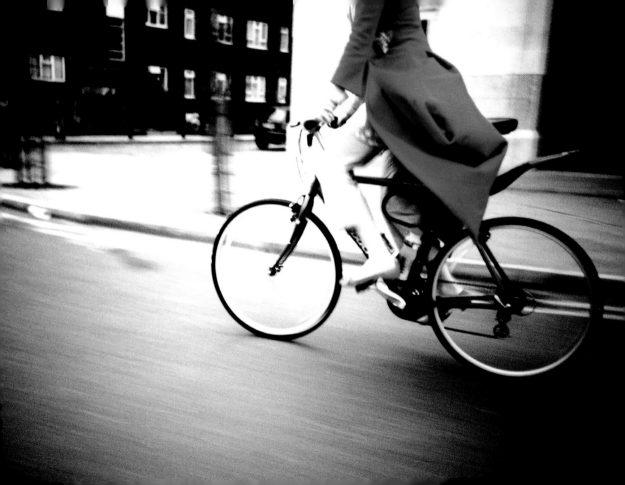

Long-range shots

This set of shots from an air show would not have worked as well if it had been bright sunny weather. For one thing, the planes would have been flying a lot higher and out of range of my camera's 32mm lens. (The lower the mm of a lens, the wider its field of vision, so if a lens has a higher mm, the field of vision is narrower and better for shooting distant objects.) Most people who go to air shows to take photographs will have a camera with a zoom lens of 200mm upward so that they can capture the detail in the aircraft. But detail is not what I was after.

Camera: Lomo LC-A [ZF]
Lens: 32mm
Focal length: 32mm
Film: Agfa Precisa 100, transparency,
 cross-processed
Shutter speed: N/A
Aperture: auto
Accessories: none
Light: overcast

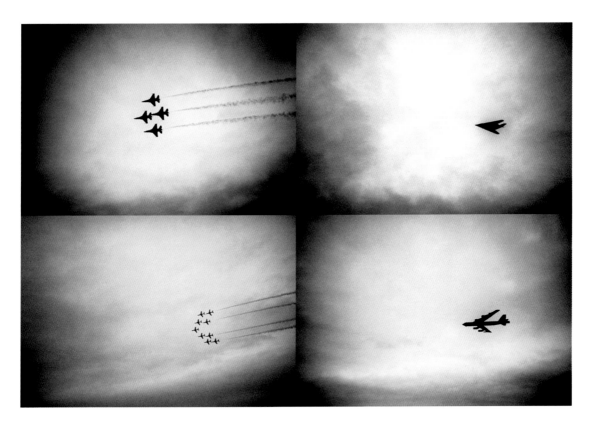

Flash photography

For this series I wanted to get a balance between the natural light in the scene and the flash. I needed to use flash because the light wasn't strong enough to illuminate the boots. If I had shot without it, I would probably have got a great background, but the boots would have been silhouetted. The key is to balance the light between the flash and the background. I got the exposure right for the background and then tried the flash at various different power settings. Hot spots, where parts of the picture are overexposed, are common with flash photography so you need to watch out for this. If something in the picture is reflecting too much of the flashlight, you should angle the camera so the light is reflected in a different direction.

Camera: Canon EOS Rebel (300D) [DSLR]
Lens: 20–35mm
Focal length: various
ISO: 800
Shutter speed: 1/60 sec
Aperture: f/4
Accessories: flash (Canon Speedlite 550EX)
Light: natural plus flash

↗ *I shot these images lying in the mud. If you know you're going to be shooting outside a lot, it's a good idea to invest in some waterproof clothing that will fit into your camera bag. It would be a shame not to get a great photo just because you were cold and wet.*

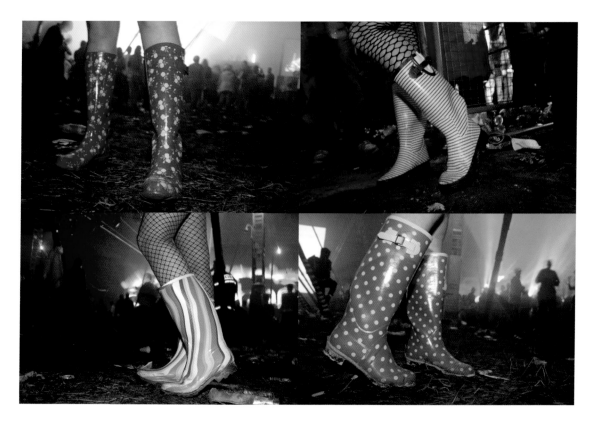

Camera protection

Photography is all about taking risks. If you're in a place where other photographers are not, you will get different shots from them. This shot works well because it presents the viewer with something remarkable. It was taken in the middle of a dust storm. The risk of tiny dust particles damaging the camera is obvious. Risks are fine, but you have to prepare for them. I encased my camera in ziplock bags and duct tape, and only opened this to change the film. I also encased my lens in plastic—so much that I couldn't change the focal length of my lens—it was stuck on 20mm. I was taking refuge in a tent, waiting for the storm to pass, when I realized that if everybody was sheltering, hardly anyone was taking photos. I grabbed my camera and went outside to take this shot.

Camera: Canon EOS-1 [SLR]
Lens: 20–35mm
Focal length: 20mm
Film: Agfa Ultra 100, negative
Shutter speed: N/A
Aperture: N/A
Accessories: tripod
Light: midday, sun in dust storm

↗ You can buy waterproof, dustproof housings, but for SLRs the cost can be prohibitive, and for digital compacts they can cost as much as the cameras they house. However, waterproof digital compacts are available for much the same price as normal compacts.

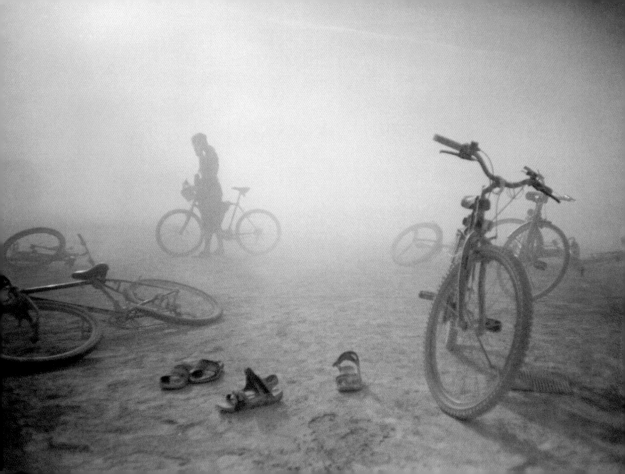

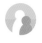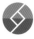

Capturing the unexpected

Sometimes it's the unexpected that makes a shot. I was trying to get an image of all three people looking out into a rough sea, but as I took the shot Sue turned away in hesitation at the thought of swimming in a cold, rough sea, and her husband, Nick, put a reassuring hand on her hip while maintaining his confident composure. Meanwhile, Henry had folded his arms, trying to keep himself warm before the inevitable dip in the icy waters. I cropped the image to give more space between the right edge and the woman, as she is looking out of the frame. There is an even light because the photo was taken early in the morning, so the sun was very low in the sky. It was shot at under 1/125 sec so you can just see some motion blur on the woman's left leg with the water dripping off it.

Camera: Contax T2 [CAF]
Lens: 38mm
Focal length: 38mm
Film: Agfa Ultra 100, negative
Shutter speed: below 1/125 sec
Aperture: N/A
Accessories: none
Light: early morning, winter

↗ *This is a particularly good example of how sharp a picture from a Contax T2 can be. Before the proliferation of compact digital cameras, the Contax T2 was renowned for being the pocket camera of choice for professional photographers.*

053

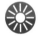

Fill flash

I wanted to get this shot, far right, from low down because that's where all the action is with paddling, so I was on my knees. You may notice that the legs of the two figures on the right are not silhouetted like the other figures in the shot. This is because I used fill flash. Fill flash lights subjects that have a strong light source behind them, in this case the setting sun. If I had moved closer, the people on the right would have been brighter: the closer the subject is to a flash, the greater the effect it has. The direction in which your camera is pointing makes a big difference when the sun is low.

Camera: Lomo LC-A [ZF]
Lens: 32mm
Focal length: 32mm
Film: Fuji Superia 100, negative
Shutter speed: N/A
Aperture: auto
Accessories: flash
Light: sunset, taken into the sun

↗ These shots were taken at the same time. The image top left was taken at a right angle to the sun; half of the people are in shadow. In the other shot, bottom left, taken with the sun behind the camera, you can see the really warm tones such a low sun creates.

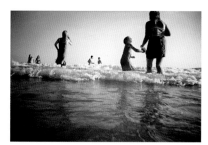

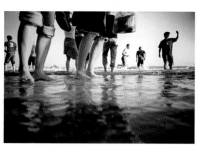

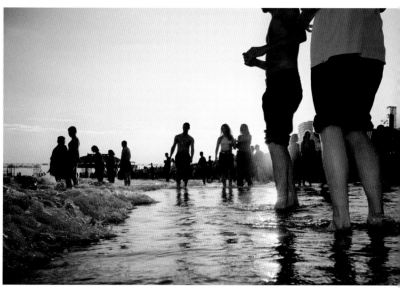

Low-horizon sunrise

This was taken just as the sun peered over the horizon. When shooting landscapes, and seascapes, it is common to include more of either the sky or the land/sea rather than placing the horizon in the middle of the picture. In this case I went for the sky as it was so spectacular, and it's the sky that makes this shot special. The trouble is that when skies look like this, they don't stay that way for long because the sun moves. Keep an eye on the sunrise and sunset times; these are displayed on many weather-forecast websites. It's best to be where you want to take the shot about 20 minutes before sunset/sunrise. Look out for very high clouds in the sky and a break in the clouds on the horizon where the sun is going to set/rise, so the light from the sun can hit the bottom of the clouds—this is what makes these great colors.

Camera: Nikon 35Ti [CAF]
Lens: 35mm
Focal length: 35mm
Film: Fuji Superia 400, negative
Shutter speed: N/A
Aperture: N/A
Accessories: none
Light: sunrise

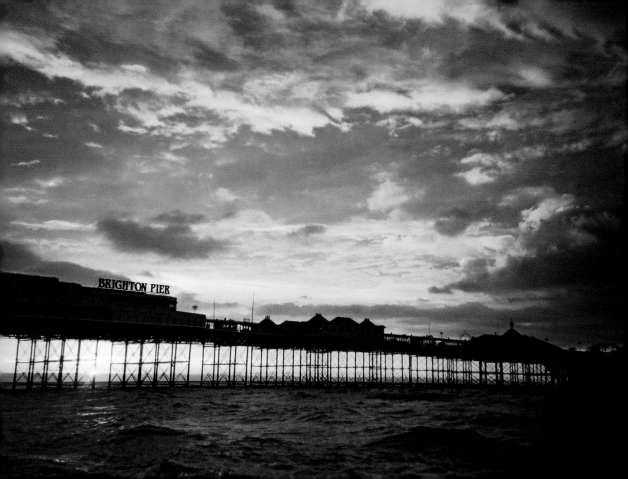

Twilight portrait

Although I am a great advocate of low-tech cameras, sometimes it pays to have something a little more advanced. This image was taken in the twilight. I shot it on a Canon EOS 5D, which is renowned for working well in low light. Because of the extreme low light, if I had shot it on a digital compact or lower-end digital SLR, it would have been very grainy. If you have a steady hand, 1/30 sec is as low as you can go with a 20mm lens without getting camera shake; any lower and you need to use a tripod, which would not have been practical in this situation: I needed to take the shot quickly, before the worm digger moved on.

Camera: Canon EOS 5D [DSLR]
Lens: 20–35mm
Focal length: 20mm
ISO: 1600
Shutter speed: 1/60 sec
Aperture: f/3.5
Accessories: none
Light: twilight

↗ You can see an example of a shot taken on a much lower-end camera—the Canon EOS Rebel (300D)—but using the same lens, under similar lighting conditions, on page 063.

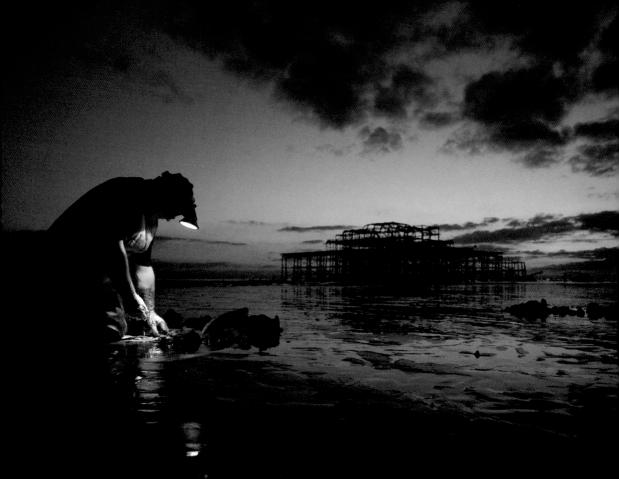

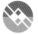

Image editing

In this shot I wanted a really bold graphic composition, but I found the daylight showing through at end of the tunnel really distracting, so I simply removed it in Photoshop. Because the forms of the cones are made up of straight lines, it is relatively simple to select the area around them. If you are going to alter your image with image-editing software, it is always a good idea to keep an original copy of the image file you are working on so that if you don't like what you have done, you can revert to the original and start again. I shot this with cross-processed slide film, which increases the contrast, and that is why the orange of the cones is really bold and stands out well against the black.

Camera: Lomo LC-A [ZF]
Lens: 32mm
Focal length: 32mm
Film: Agfa Precisa 100, transparency,
 cross-processed
Shutter speed: N/A
Aperture: auto
Accessories: none
Light: shade

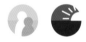

ISO settings

I woke up at 7 A.M., looked out the window, saw there was snow on the ground, and knew the swimmers would still be crazy enough to go for their morning dip in the sea. I grabbed my camera and got down to the beach. I have plenty of shots of the Brighton swimmers taking a dip in the winter months, but to be fair, if the sky is gray in a shot you can't tell whether it was taken in the summer or the winter. Obviously, what makes this shot is the fact that there are two people on the beach in just their swimsuits, with snow on the ground. This shot is quite noisy (grainy). I shot on 1600 ISO (the camera's maximum setting) because of the dark conditions: the higher the ISO, the grainier the picture.

Camera: Canon EOS Rebel (300D) [DSLR]
Lens: 20–35mm
Focal length: 20mm
ISO: 1600
Shutter speed: 1/60 sec
Aperture: f/7.1
Accessories: Lowepro Photo Gloves
Light: natural, early morning, winter, overcast

↗ You can see an example of a shot taken at 1600 ISO on a higher-quality digital camera, which is clearly less grainy, on page 059, and of one taken on a black-and-white 1600 ISO film on page 019.

Cross-processing

This type of shot is particularly well suited to cross-processing because what would typically appear boring is made much bolder. If it is bright and sunny, it is always best to have the sun behind you for such a shot, or you risk it turning into a silhouette. I took these while traveling; the signs interested me because they are not what I am used to seeing at home. As a photographer, always try to keep interested in the everyday and mundane because what might not be immediately striking to you in its everyday context might be interesting to people viewing your work, and can be made intriguing by the way you frame and photograph it. That said, I can't remember the last time I took a shot of a road sign at home; to be honest, I don't always practice what I preach.

Camera: Lomo LC-A [ZF]
Lens: 32mm
Focal length: 32mm
Film: Agfa Precisa 100, transparency, cross-processed
Shutter speed: N/A
Aperture: auto
Accessories: none
Light: bright sun

↗ If you are shooting with digital, you can always up the contrast and saturation in Photoshop. I explain how to do this in Color correction on page 202.

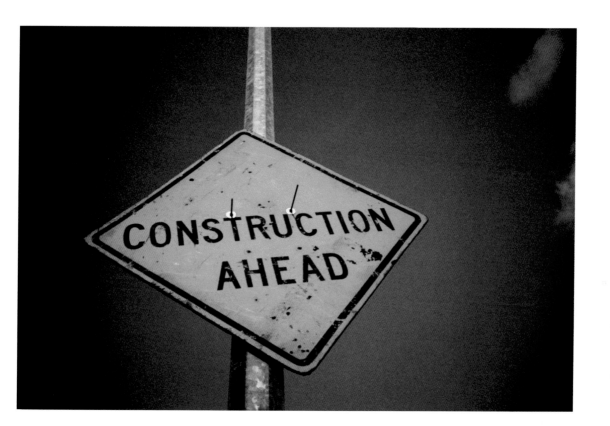

Cross-processing continued

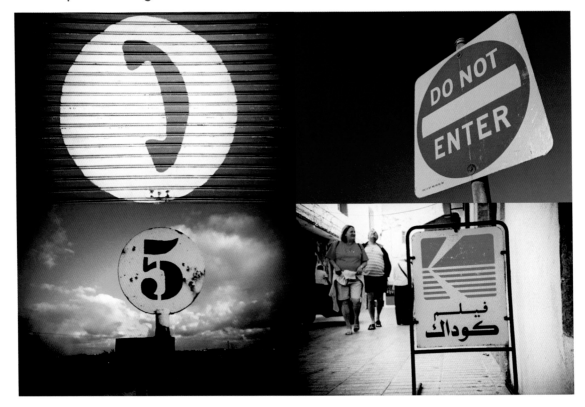

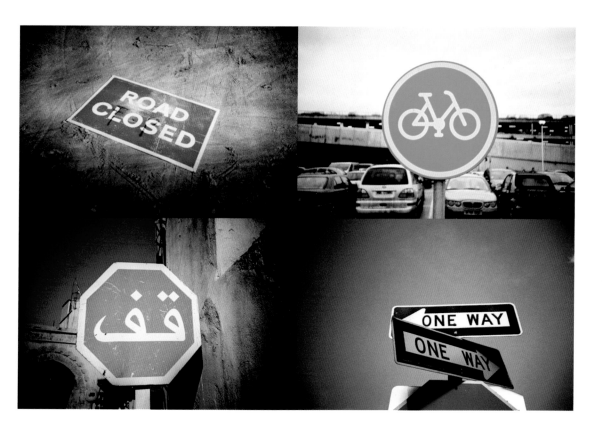

Low point of view

Sometimes it's not good enough to place your camera on the floor and take a shot blindly. If you are trying to get something specific in frame, you have to lie on the floor to look through the viewfinder. For this shot I needed to be as low as possible, otherwise the horizon would have been much higher in the frame and the bottom half of the cyclist would have been lost in its black silhouette. If I am working on a project that I know will involve a lot of low-down photography, I take a yoga or camping mat to lie on so I don't get dirty. (If push comes to shove, a cardboard box will do.) It's not so bad if you're shooting on grass (unless it has been raining!). And a mat doesn't just stop you from getting dirty; on a sunny summer's day it can get very uncomfortable on hot tarmac.

Camera: Nikon 35Ti [CAF]
Lens: 35mm
Focal length: 35mm
Film: Agfa Ultra 100, negative
Shutter speed: N/A
Aperture: N/A
Accessories: none
Light: natural, looking into the sunset

↗ You can see from this shot that sunsets are generally not that spectacular when there are no clouds in the sky; look at the difference in the photo on page 057.

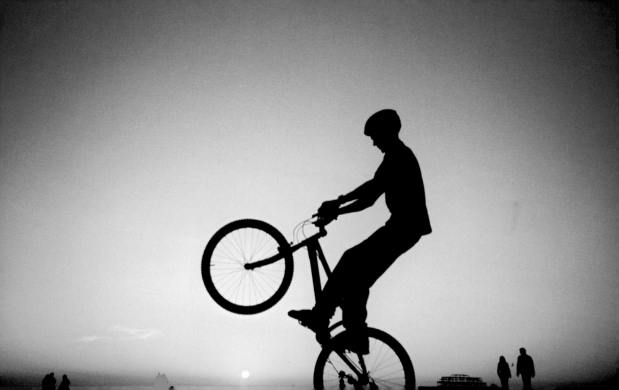

Narrow-focus portrait

This is a great example of how warm the light is as the sun is setting. You can see how low the sun is in the sky from the length of the subject's shadow in the bottom right of the frame. It can be quite difficult to get good-looking shots in the midday sun because of the harsh shadows, so set that alarm clock early. This photo shows that you don't need to have the whole person in the shot to take a portrait; after all, the reason I took the photo of this guy was his rather striking shorts. I used a very large aperture (small f-number) to get a narrow depth of field so that only the figure is in focus. As the background is quite busy, it would detract from the main subject if it were in focus. If I had taken a wider shot to include the boy's face, he would have been a lot smaller in the image—this way there is no mistaking what the image is about.

Camera: Canon EOS-1 [SLR]
Lens: 50mm
Focal length: 50mm
Film: Agfa Ultra 100, negative
Shutter speed: N/A
Aperture: N/A
Accessories: none
Light: sunset, clear sky

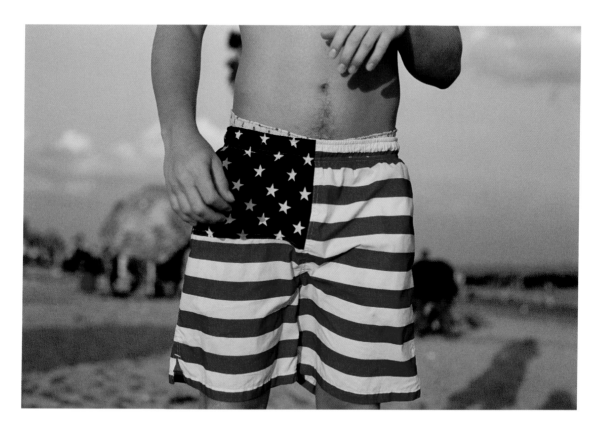

Landscape with polarizer

A sky can be made to look more dramatic through the use of a circular polarizing filter. Circular polarizers are used to reduce the light reflected from windows, water, and other reflective surfaces. A lot of the light that we see in the sky is reflected off water particles in the atmosphere, and this is what makes the sky blue. Removing some of this reflected light makes the sky appear darker. Filters are most often used with SLRs/DSLRs because their lenses have screw threads that allow you to screw filters onto them, but if you are using a compact camera there is no reason why you can't just hold the filter in front of the lens when you take a picture—it will have the same effect.

Camera: Canon EOS-1 [SLR]
Lens: 20–35mm
Focal length: 20mm
Film: Agfa Ultra 100, negative
Shutter speed: N/A
Aperture: N/A
Accessories: circular polarizer
Light: afternoon, bright sun

↗ *If you are going to use a polarizing filter with an autofocus camera, make sure you get a circular polarizer and not a linear polarizer because autofocus does not work with linear polarizers.*

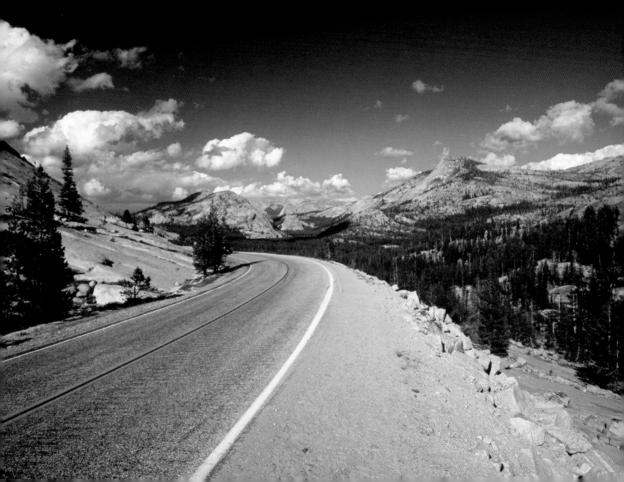

Action portrait

I thought that Dave bodysurfing would make an interesting shot so
I positioned myself close to him and focused on him, as much as you
can focus with a Nikonos-V: like the Lomo LC-A, you don't actually
see what is in focus by looking through the viewfinder. You have to
estimate the distance to the subject, so it can be a bit hit-and-miss.
Because I knew that Dave might move at any point, I closed down the
aperture to f/16. The large depth of field this gave meant that if he did
move, either closer to or further away from me, he would still be in
focus. I couldn't close down the aperture any more than that because
the shutter speed might then have dropped to 1/60 sec or lower, and
that would have resulted in an image that was motion-blurred.

Camera: Nikonos-V [NiV]
Lens: 35mm
Focal length: 35mm
Film: Fuji Superia 400, negative
Shutter speed: 1/125 sec
Aperture: f/16
Accessories: none
Light: early morning, overcast

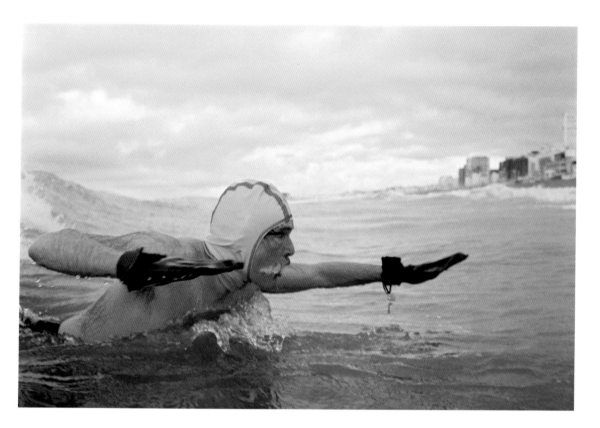

Portrait in silhouette

If you are in a dark environment and you don't want to use a flash, and you're not too bothered about capturing the face of the person you are shooting, why not try capturing a silhouette? If you are going to try this and your camera has autoflash, turn it off. To make this silhouette more dynamic, I found a wall with a spotlight casting an oval shape on it and used this to frame the subject. She's not quite silhouetted; if you look closely you can just make out her nose, cheeks, and forehead, which means there must have been a weak light source behind me.

Camera: Lomo LC-A [ZF]
Lens: 32mm
Focal length: 32mm
Film: Fuji Superia 400, negative
Shutter speed: N/A
Aperture: N/A
Accessories: none
Light: artificial indoor, dark

↗ This photo is a good example of the use of negative space. Negative space is the space around the subject, in this case the oval shape on the wall that has helped define the figure. (Another example of the use of negative space can be seen on page 025.)

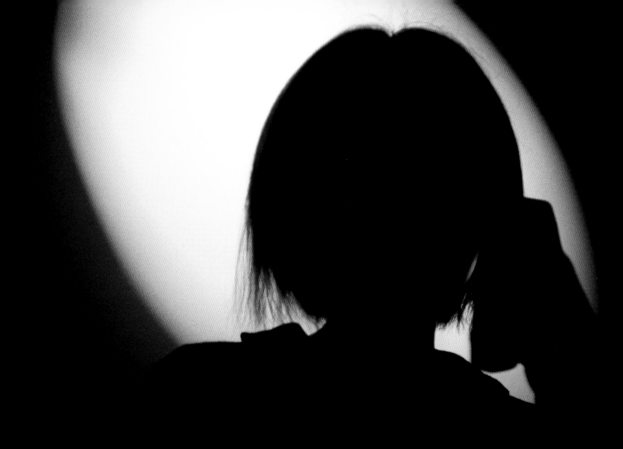

Tripod shot

I used a beanbag tripod for this shot. Beanbag and mini tripods fit into a bag easily, and in this case, because I had to scramble down a cliff path to get to the beach, it was a good thing I wasn't holding a full-size tripod. One drawback of beanbag tripods is that you have to use a cable release, or self-timer, to take the photo as they are not stable enough to prevent movement if you touch the camera. In addition, if you want to set your camera higher, you have to find something to rest it on. For this shot I used a rock. Another disadvantage is that you can't angle your camera up and down by more than about 30 degrees.

Camera: Canon EOS-1 [SLR]
Lens: 50mm
Focal length: 50mm
Film: Agfa Ultra 100, negative
Shutter speed: N/A
Aperture: N/A
Accessories: beanbag tripod,
 cable release
Light: dusk

↗ It's always a good idea to keep a flashlight in your camera bag because when it gets dark it becomes very hard to find all your accessories.

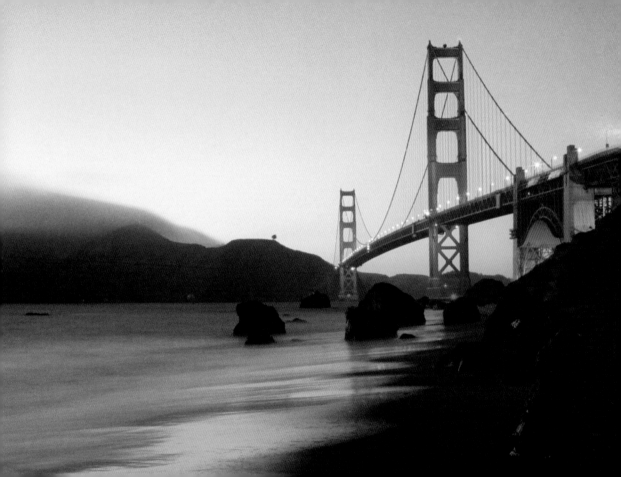

Cropping and scale

When it comes to taking photos of well-known landmarks, you can take up the challenge to do something slightly different from emulating a postcard shot; not that I am saying this is in any way original. Most people's immediate response would be to try to get the whole tower in frame, but what's the point? We all know what the Eiffel Tower looks like, and I'm sure most people could draw a pretty decent rendition from memory. I included the traffic light in the shot to give the tower a sense of scale: people know roughly how big a set of traffic lights is, so this helps give the viewer an idea of how big the Eiffel Tower really is.

Camera: Nikon 35Ti [CAF]
Lens: 35mm
Focal length: 35mm
Film: Kodak Gold 200, negative
Shutter speed: N/A
Aperture: N/A
Accessories: none
Light: night, ambient

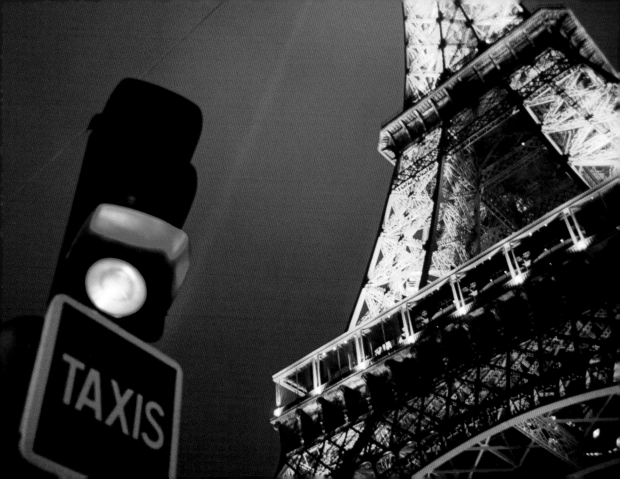

Night photography

I wanted to get this shot without any people, and luckily there wasn't anyone around. Because it was shot at night, I knew it was going to need a long exposure, but I didn't have a tripod with me, so I positioned the camera with its base flat on the ground to keep it steady, then pressed and held the shutter button until the shutter released itself again. In dark conditions, when you press and hold the shutter button down on a Lomo LC-A and similar cameras (see list on page 192) you will hear a click. This is the shutter opening. You will hear a second click when it closes. Depending on how dark it is, this can be upward of 10 minutes, so make yourself comfortable and try not to move the camera. If you release the shutter button before the second click, you will end the exposure too early and your photo will be underexposed.

Camera: Lomo LC-A [ZF]
Lens: 32mm
Focal length: 32mm
Film: Agfa Precisa 100, transparency,
 cross-processed
Shutter speed: N/A
Aperture: auto
Accessories: none
Light: night, street lighting

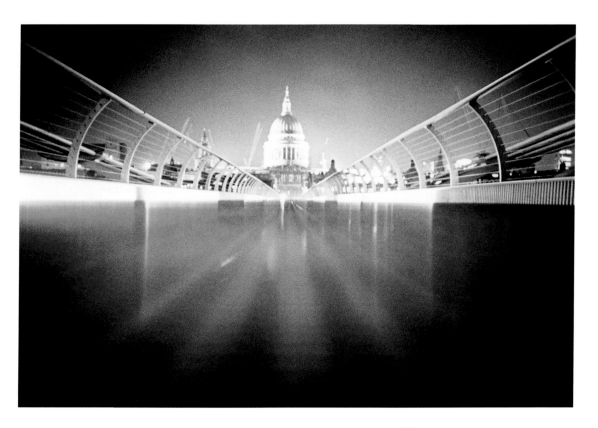

Infinity focus

What makes this image is that the characters appear to be eyeing up the shiny new bike. The camera was resting on the ground and the focus was set to infinity, making the foreground out of focus. If you are using a compact digital camera or a compact film camera with autofocus, if you have the option to turn off the autofocus and set it to infinity do so, otherwise the camera might try to focus on the ground closest to it.

Camera: Lomo LC-A [ZF]
Lens: 35mm
Focal length: 35mm
Film: Agfa Precisa 100, transparency, cross-processed
Shutter speed: N/A
Aperture: N/A
Accessories: none
Light: afternoon, overcast

↗ *It wasn't my intention to have the characters looking at the bike—I only noticed that afterward. It's not a good idea to delete photos before you view them on a computer screen: you won't notice all the details on your camera's LCD screen.*

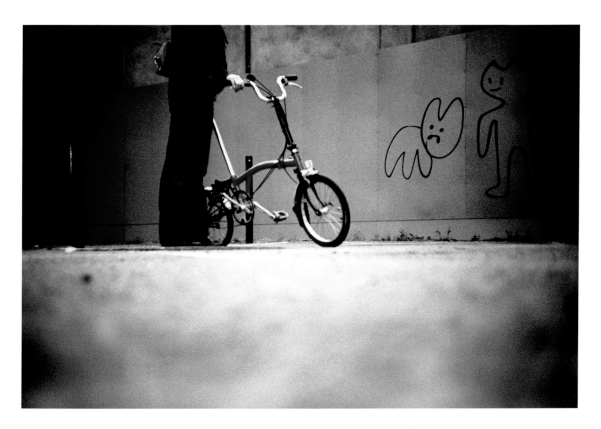

Composition and scale

I included the subject's toes in this shot to give a better sense of scale, but focused on her face. I used to go swimming with my Lomo LC-A (only on very calm days), keeping just the hand that was holding the camera above the water. Even though I was careful, I still had to wind on the film with both hands, which meant a little seawater got on the camera. A few months later the distance/focusing switch rusted tight. It was worth it to me to get this great picture of my mother, but don't feel tempted to take even a few shots in the water if your camera isn't waterproof. You can get waterproof housing for a lot of digital cameras, and there are plenty of waterproof compact digital cameras that look and cost the same as a normal compact. And if you only want to shoot on the water as a one-off, you can get a disposable waterproof camera.

Camera: Lomo LC-A [ZF]
Lens: 32mm
Focal length: 32mm
Film: Agfa Precisa 100, transparency,
 cross-processed
Shutter speed: N/A
Aperture: N/A
Accessories: none
Light: morning, overcast

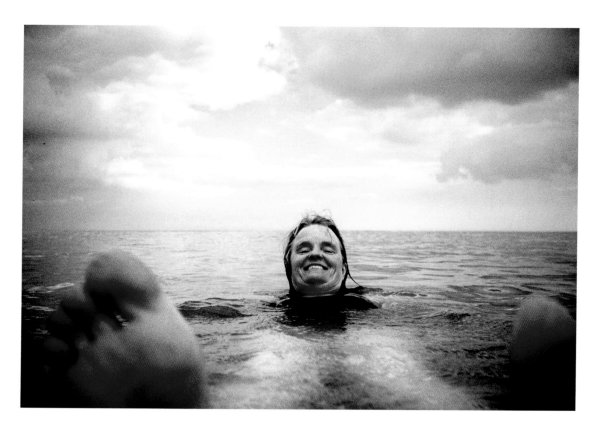

Flat lighting

This was shot on an overcast day, which meant I got really flat lighting. On an overcast day the sun hits the cloud cover, and it disperses the sun's light in all directions so there are no strong shadows cast. If there were strong sunlight in this image there may have been shadows cast by the railings on the sides of the pier. In my opinion, cross-processing comes into its own with shots taken on overcast days because when you have flat lighting, you have less contrast in an image; as cross-processing bumps up the contrast, it helps to bring it back. I had to wait quite a while to get the shot without any people in it—well worth the wait I think. The lack of people really helps give the shot a spooky feeling, which is appropriate because, in Bram Stoker's *Dracula*, Whitby is where Count Dracula arrived in England on his little kill fest.

Camera: Lomo LC-A [ZF]
Lens: 32mm
Focal length: 32mm
Film: Agfa Precisa 100, transparency, cross-processed
Shutter speed: N/A
Aperture: auto
Accessories: none
Light: afternoon, overcast

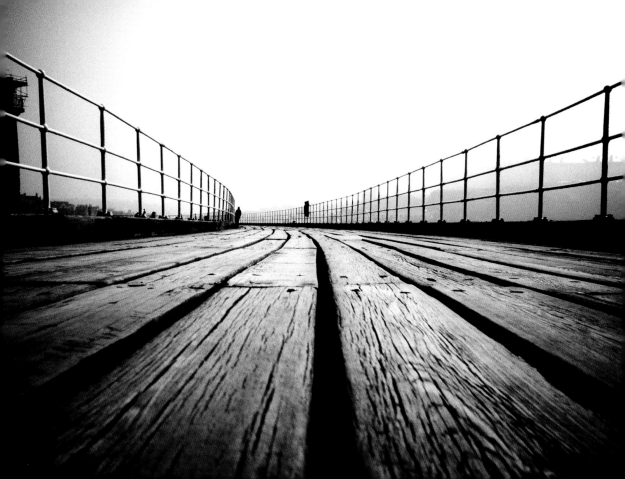

Long depth of field

I wanted all the boats to be in focus, which needed a long depth of field, so I closed the aperture down. Some SLRs have a depth-of-field preview button that allows you to see what will be in focus with a particular aperture. When you look through the viewfinder of an SLR, you are looking through the lens with the aperture at its widest; it only closes down when you press the shutter button. When you preview the depth of field, you might see parts of the picture jump into focus—these are the only parts that will be in focus in the shot. If you are shooting on digital and don't have a preview option, you can take the picture and zoom on the LCD screen to check whether what you wanted is in focus.

Camera: Canon EOS 5D [DSLR]
Lens: 50mm
Focal length: 50mm
ISO: 400
Shutter speed: 1/32 sec
Aperture: f/11
Accessories: circular polarizer
Light: bright sun

↗ *Because of my love affair with super-saturated colors, I upped the saturation of this image in Photoshop when post-processing it.*

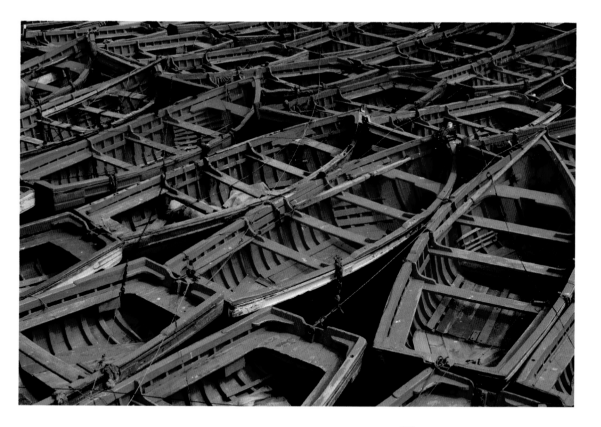

Up-close composition

People always have a hard time working out what this photo is of, how it was taken, or whether it is a double exposure, but it is simply a section of poster on a bus-stop billboard. The three bright vertical areas are caused by the striplights behind the poster. If you get up close to everyday objects, there are all sorts of weird and wonderful compositions that can be made. If you are trying to take photos like this, remember to use the rule of thirds when positioning the elements of the shot: this will help make your composition more striking.

Camera: Lomo LC-A (ZF)
Lens: 32mm
Focal length: 32mm
Film: Fuji Superia 400, negative
Shutter speed: N/A
Aperture: N/A
Accessories: none
Light: backlighting from billboard
 striplights

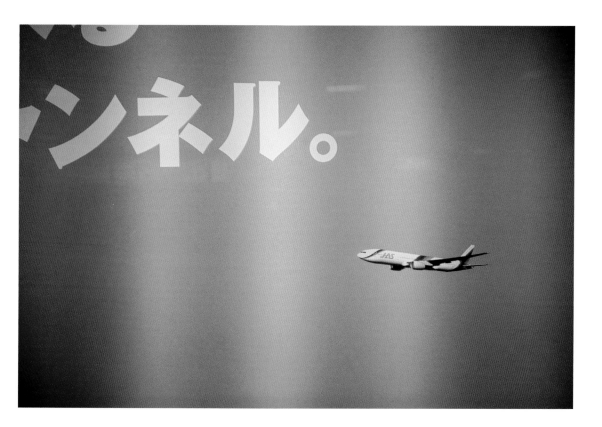

Selective framing

In this photograph I have cut off the top of the tower on the right to give the impression that it is much higher than it actually is. In fact, the top of the building is just out of the frame. I shot on Agfa Precisa slide film and then cross-processed. When Agfa Precisa is cross-processed it really brings out the blues, which is why the sky is such a strong shade of blue. Other brands of film have different color biases. Because this was shot on a bright day, the contrast was really harsh; you can see that all the shadow in the shot is completely black.

Camera: Lomo LC-A [ZF]
Lens: 32mm
Focal length: 32mm
Film: Agfa Precisa 100, transparency, cross-processed
Shutter speed: N/A
Aperture: auto
Accessories: none
Light: bright sun

↗ The dark corner is the result of lens vignetting; this is caused by what some say is an imperfection in the Lomo LC-A's lens. The lens-vignetting effect is intensified by cross-processing because cross-processing increases the contrast in an image.

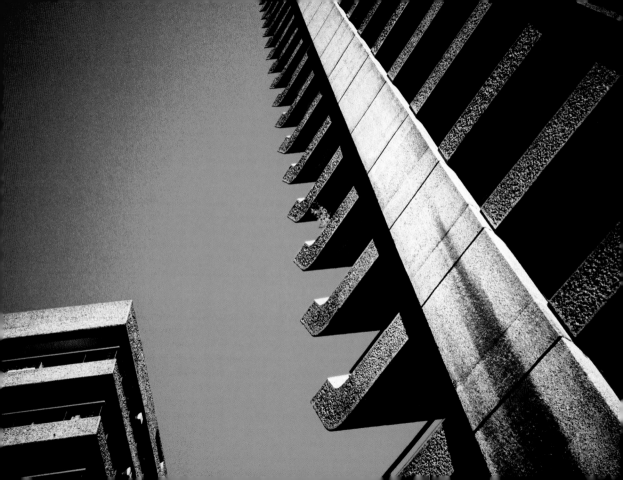

Contrasting colors

This floor is actually a gray/yellow, but because of the artificial lighting in the store it appears green. If I had taken this with a digital camera, with auto white balance turned on, it would have tried to compensate for the green bias in the store lighting. White balance tries to make whites appear white. You can see that this shot definitely has a green tint because I am wearing a pair of black-and-white Converse All Stars and the white toe parts appear green. I didn't realize this at the time. One of the reasons this shot works so well is because of the contrast between the green of the floor and the red of the writing. In basic color theory, colors on opposite sides of the color wheel, like green and red, contrast. Look for contrasting colors, but don't go mad, as you don't want to give people headaches.

Camera: Contax T2 [CAF]
Lens: 38mm
Focal length: 38mm
Film: Agfa Ultra 100, negative
Shutter speed: N/A
Aperture: N/A
Accessories: none
Light: artificial indoor

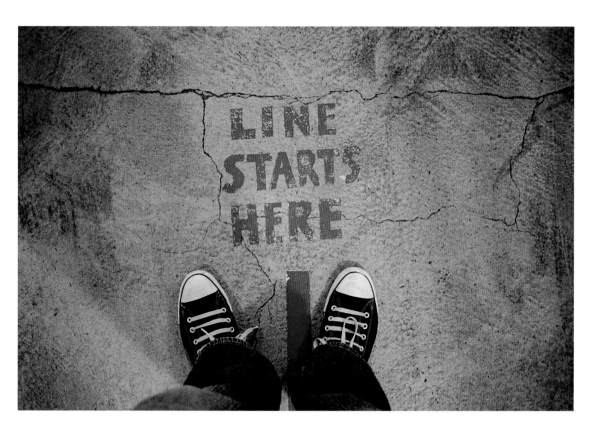

Unusual camera position

If you want people to notice your photography you have to make your shots look different from others. One of the things you can do to get an original shot is to take your camera everywhere so that you never miss an opportunity. This was taken at the top of a waterslide, not normally a place you would take your camera, but because I had a friend with me I was able to pass it over to him before I took the plunge. To get the shot I held the camera between my legs, roughly 80cm (c. 2ft 8in) from my feet: this is the Lomo LC-A's minimum focus distance. In such watery situations, be careful not to get your camera wet!

Camera: Lomo LC-A [ZF]
Lens: 32mm
Focal length: 32mm
Film: Fuji Provia 100, transparency
Shutter speed: N/A
Aperture: auto
Accessories: none
Light: artificial indoor, low

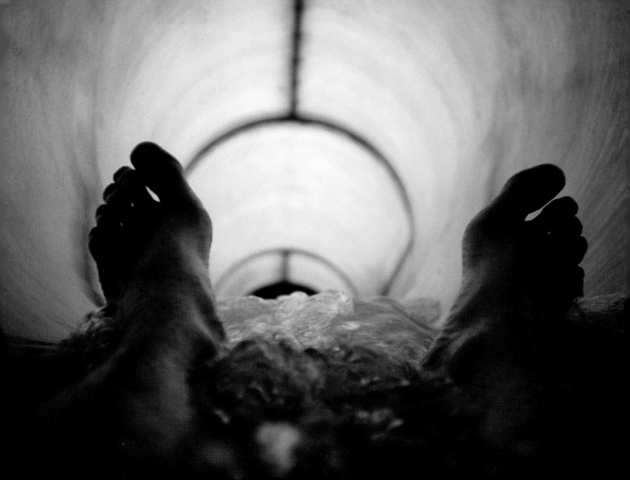

Anticipating a shot

To get this shot I set the focus of my Lomo LC-A to 80cm (c. 2ft 8in), then approached the bird with my finger on the shutter button so I could take the shot as soon as I thought he was going to fly. It was just luck that the bird started to flap when I was 80cm from him. I had tried this many times before and never got anything as good, so it just shows—try, try, and try again and you will succeed. If I had shot this on an SLR I would have set the aperture to f/11 or above to give a wide depth of field, and thus a greater margin for error, to allow for the bird moving closer or farther away. To avoid any delay with the camera focusing when I pressed the shutter button, I would have set the camera to manual focus, and the focus to around 80cm.

Camera: Lomo LC-A [ZF]
Lens: 32mm
Focal length: 32mm
Film: Agfa Precisa 100, transparency, cross-processed
Shutter speed: N/A
Aperture: auto
Accessories: none
Light: late afternoon, clear day

↗ I am not a big fan of the zoom lens. I believe, to the viewer, there is something unnatural about photos taken with a telephoto or zoom lens. An image captured with a 32mm lens is a lot closer to what your eyes see than one captured with a 200mm zoom lens.

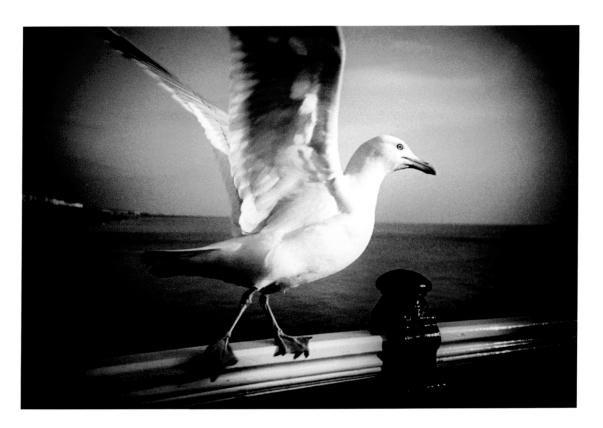

Subject's-eye view

Even though I am not a dog lover I must admit I do like a good dog shot, as long as it's not too sickeningly cute. I find that to get the best dog shots you have to get down to their level so it appears that the shot is taken from a dog's-eye view. Such a "low-down" shot will work better because people are more used to looking down at dogs; by taking shots from the dog's point of view you are presenting the viewer with a perspective they are not used to, which generally makes an image more interesting. Dogs are naturally curious, so be careful that you don't get your lens cleaned with dog saliva! You don't have to get on the ground yourself; you are better off holding the camera close to the ground and pointing it in the direction of your furry friend.

Camera: Lomo LC-A [ZF]
Lens: 32mm
Focal length: 32mm
Film: Agfa Precisa 100, transparency,
 cross-processed
Shutter speed: N/A
Aperture: auto
Accessories: none
Light: afternoon, bright sunny day
 in the shade

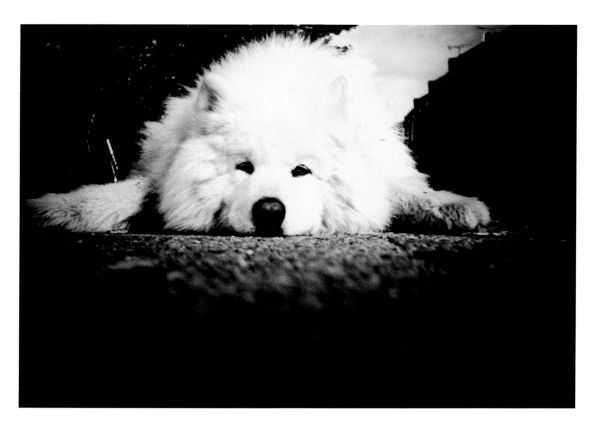

Rule of thirds

This was taken in the small fishing town of Essaouira on the Moroccan coast. A wall exactly the same as the one in shot was behind me, casting its shadow on the one in front. This composition is a classic example of the use of the rule of thirds: the top of the wall is exactly one-third down from the top of the image, and the bottom of the shadow is one-third up from the image's bottom edge. (See page 180 for more on the rule of thirds.) The strip of wall that is not in shadow, taking up the middle third of the image, produces a pattern much like a zipper.

Camera: Lomo LC-A [ZF]
Lens: 32mm
Focal length: 32mm
Film: Agfa Ultra 100, negative
Shutter speed: N/A
Aperture: auto
Accessories: none
Light: sunset, clear day

↗ *The wall is actually a light cream, but the combination of the warm light from the setting sun and my use of Agfa Ultra to increase the saturation in the shot has rendered it a more golden color.*

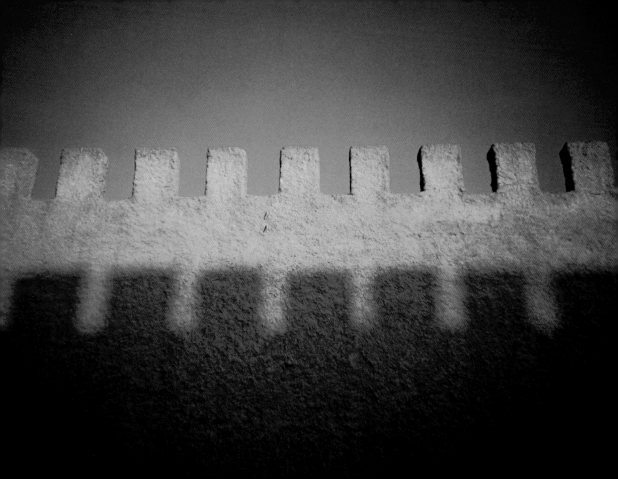

Child's portrait

I like to photograph children doing something natural because if you try to make them sit for a shot they will get very bored very quickly. For this photo I placed the camera on the desk and took a quick look through the viewfinder to make sure the girl was in shot. I placed the camera at the girl's level so that the shots were taken from a child's-eye view. Most people would take a shot looking down at the child. I left the camera where it was so that when she started drawing again, I could shoot without distracting her by looking through the viewfinder, then I waited for what I thought was an interesting pose, then took my shots.

Camera: Cosina CX-2 (ZF)
Lens: 35mm
Focal length: 35mm
Film: Agfa Precisa 100, transparency
Shutter speed: N/A
Aperture: auto
Accessories: none
Light: indoor striplighting

↗ Another advantage of placing the camera on the desk was that it helped me avoid camera shake, as I was shooting under weak lighting, without a flash.

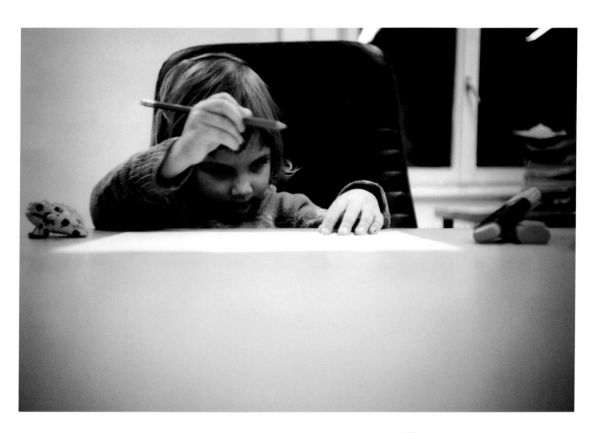

Neutral density filter

Most long-exposure shots are taken at night and/or in dark places, but it is possible to take them during the day by using a neutral density (ND) filter. These filter out all types of light equally, which means you can set longer shutter speeds or open up your aperture without overexposing the shot. They are available in different strengths. For this shot I used an ND8; with the filter attached the shutter speed required went up from 1 to 8 seconds. I wanted a long exposure to make the sea look like mist. Over the 8 seconds that the camera recorded the scene, the water was moving a lot, so it appears motion blurred, and that's what creates the misting effect. You can see white streaks in the bottom right of the frame where the water has washed over the stones and retreated.

Camera: Canon EOS 5D (DSLR)
Lens: 20–35mm
Focal length: 20mm
ISO: 50
Shutter speed: 8 sec
Aperture: f/9
Accessories: neutral density filter, tripod, cable release
Light: afternoon, very overcast

↗ *Neutral density filters don't work on many cameras other than SLRs because of the way the metering works.*

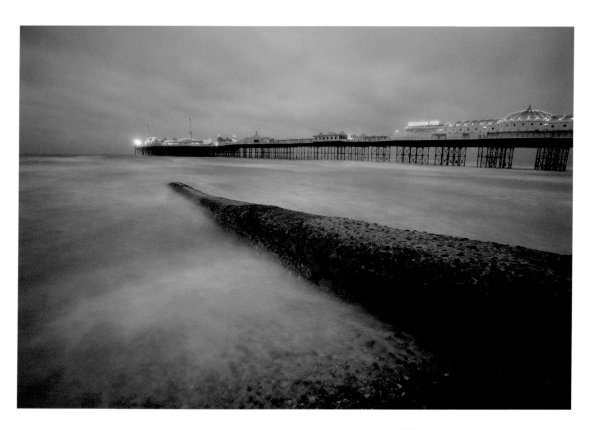

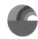

Colored flash

These seagulls were flocking around fishermen who were throwing away entrails after gutting their catch. All I had to do was wait by the fish guts for the birds to start flocking around me and their free dinner. If you aren't lucky enough to be surrounded by fish guts you can use birdseed or leftover food scraps to entice birds. The sun had gone down so there wasn't a lot of light around, and the birds would have come out as silhouettes if I hadn't used a flash. In this case I decided to mix it up a little and use the Colorsplash Flash set to yellow. You can get some surreal effects with the Colorsplash when you use it outside because it will only color objects that are close to you; in this case the seagulls are yellow, but the sky has remained blue.

Camera: Lomo LC-A [ZF]
Lens: 32mm
Focal length: 32mm
Film: Agfa Ultra 100, negative
Shutter speed: N/A
Aperture: auto
Accessories: Colorsplash Flash
Light: dusk, clear day

↗ *You can also achieve this effect by placing a colored gel over your regular flash. You can see other shots for which I used a colored flash on pages 009 and 133.*

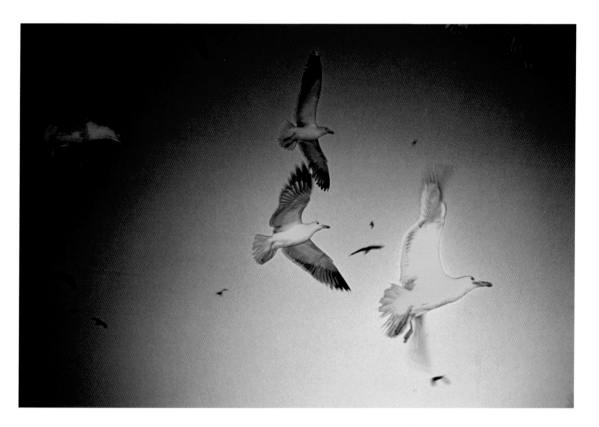

Multiple shots

This shot was taken as the sun was coming up. I noticed that sometimes when Henry raised his arm out of the water it blocked out the sun, and I knew this would make a great image. With this kind of shot you just have to take it over and over again to get it right. I took seven shots to get this one; ironically, this was the second of the set.

Camera: Nikonos-V [NiV]
Lens: 35mm
Focal length: 35mm
Film: Kodak PORTRA 400VC, negative
Shutter speed: N/A
Aperture: N/A
Accessories: none
Light: sunrise

↗ A common problem when shooting on the surface of water is that you can get water drops on the lens and these cause blurry areas on the photo. This can be avoided simply by licking the lens because the water drops can't adhere to saliva.

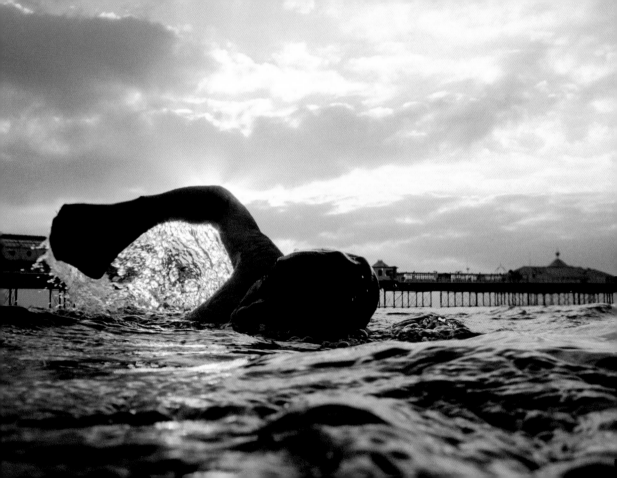

Close-up portrait

This guy was clearly taking no chances with breathing in the desert dust. The general consensus is that portraits should be shot on a lens of between 50 and 100mm: any lower than that and you get a distorted image in which the nose becomes bigger and the face starts to look odd and bulbous; any higher and it just becomes impractical because you are so far away from your subject you have to shout to give them direction. But this was shot on my 20–35mm lens. One of the drawbacks of using such a wide lens is that you have to be really close to your subject to get their face to fill the frame—typically between 20 and 50cm (c. 8in and 1ft 8in)—so it really forces the subject to interact with you.

Camera: Canon EOS-1 (SLR)
Lens: 20–35mm
Focal length: 20mm
Film: Agfa Ultra 100, negative
Shutter speed: N/A
Aperture: N/A
Accessories: circular polarizer
Light: bright sunshine

↗ I think the slightly distorted image fits the bizarre environment of the Burning Man Festival (Black Rock Desert, Nevada). For another shot taken at this festival, see page 141.

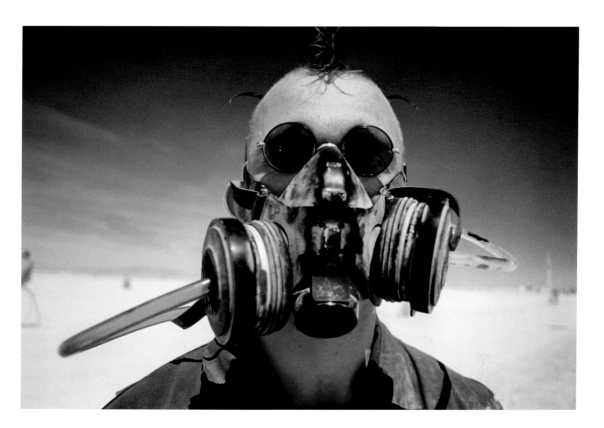

Contrast

Cross-processing can really help make your shots stand out. Admittedly there is nothing very special about the composition of this shot—I am sure it has been snapped in such a way a great many times before—but what does make this shot a little different is the increased contrast the cross-processing has produced. I took it in the middle of the day when the sun was at its strongest so it has produced really strong shadows on Lady Liberty, and the wispy clouds add a sense of drama to the shot.

Camera: Lomo LC-A [ZF]
Lens: 32mm
Focal length: 32mm
Film: Agfa Precisa 100, transparency, cross-processed
Shutter speed: N/A
Aperture: auto
Accessories: none
Light: midday, bright sun

↗ *I have used another technique to make my photo of the Eiffel Tower stand out (see page 081).*

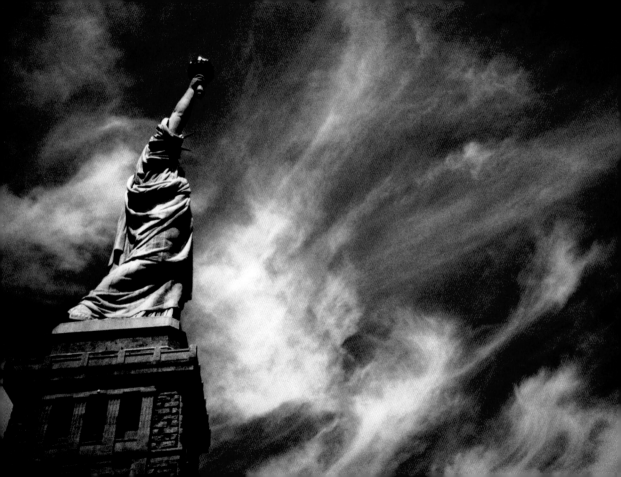

Photo narrative

To build up a narrative for this set I got various shots of Julia in different parts of the frame—one shows her smiley face, another just her legs—to make it look like I was unable to capture her movement as she shot skyward. When I was taking these shots I got down low not because she was going so high, but because I was trying not to get any of the nearby pier or promenade in the shots: it's the uncluttered backgrounds that make these pictures.

Camera: Lomo LC-A [ZF]
Lens: 32mm
Focal length: 32mm
Film: Agfa Precisa 100, transparency, cross-processed
Shutter speed: N/A
Aperture: auto
Accessories: none
Light: midday, bright sun

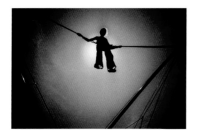

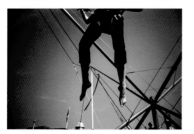

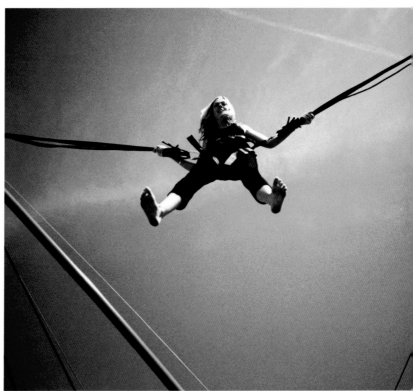

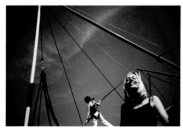

Manual focus

This series was taken during a cycle race at the Commonwealth Games in Manchester, England. I kept the camera in the same position so that I could build up a set, but to give it a bit of variety I included a shot of the event ambulance and a closeup of a bike wheel. I shot these with my Lomo LC-A so that when I pressed the shutter button the photos were taken immediately, with no shutter lag. If you are going to take this sort of shot on an SLR, you need to set your focus to manual and focus on where the bikes will be when they pass you. If your camera is set to autofocus it will have difficulty focusing on the bikes as they all whiz past.

Camera: Lomo LC-A [ZF]
Lens: 32mm
Focal length: 32mm
Film: Agfa Precisa 100, transparency, cross-processed
Shutter speed: N/A
Aperture: auto
Accessories: none
Light: broken cloud

↗ I kept the camera steady for these shots so that the riders were motion-blurred; the image on page 045 is a good example of what happens if you pan with a moving subject.

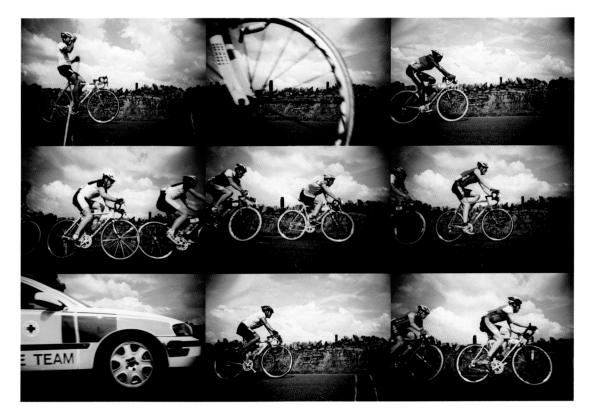

Silhouettes

Silhouettes are all about composition, so take time composing the shot. Don't feel you always have to get the whole subject into a silhouette shot—you can go for just a small part of it. If you are using a modern camera you have to be careful that it doesn't try to expose the object you want to be in silhouette. If you find this has happened, after checking the LCD screen on your camera, you should use exposure compensation to underexpose the shot so that the silhouette will be blacker. (For more on exposure compensation, see page 138.)

Camera: Lomo LC-A [ZF]
Lens: 32mm
Focal length: 32mm
Film: Agfa Precisa 100, transparency, cross-processed
Shutter speed: N/A
Aperture: auto
Accessories: none
Light: bright sunlight

↗ *The Lomo LC-A is great for silhouette shots; using a Lomo LC-A combined with cross-processing, you are virtually guaranteed deep blacks and punchy blue skies.*

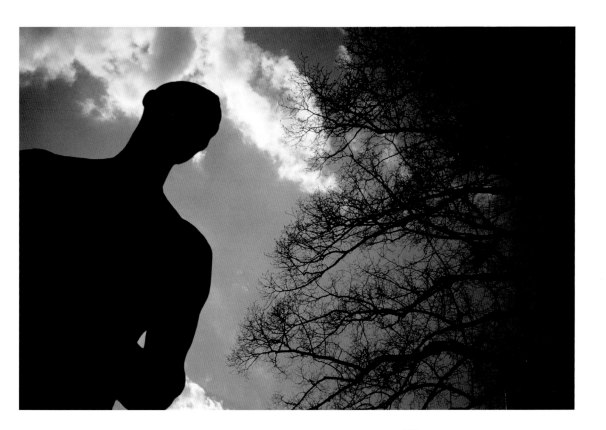

Silhouettes continued

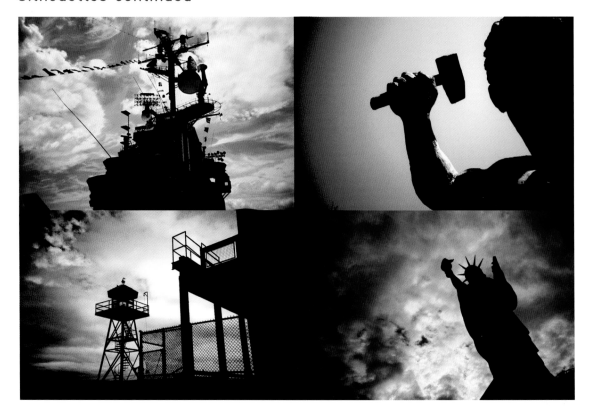

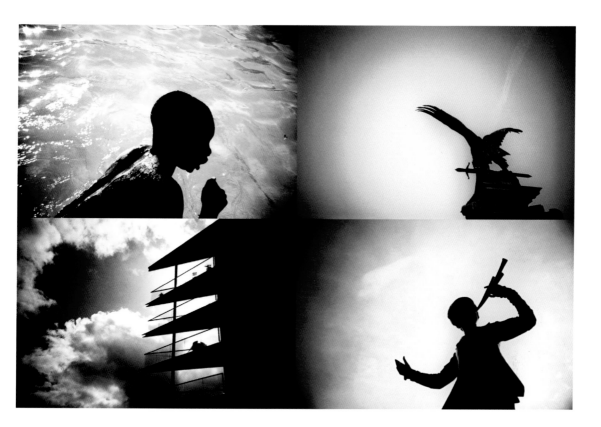

Product shots

A lot of the time products just end up being shot in a studio on white backgrounds. This is fine for showing the product, but if you have to flip through a book of 40 shoe photos it can get a bit boring. Tom Phillips, the creative director on this job, had the idea to shoot the product in different locations around the city, on various backgrounds. Most of my time was spent spotting locations that would not divert the viewer's attention from the product. The only shot that got a bit of a cityscape in the background was the nighttime photo (bottom left). Because it was dark, the aperture opened right up and gave me a narrow depth of field, which meant the background was thrown out of focus.

Camera: Lomo LC-A [ZF]
Lens: 32mm
Focal length: 32mm
Film: Fuji Reala 100, negative
Shutter speed: N/A
Aperture: auto
Accessories: tripod, cable release
 (for night shot)
Light: varied conditions

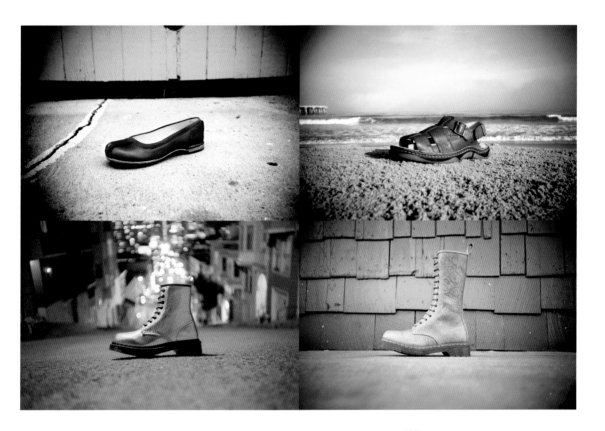

Camera tossing

Camera tossing is exactly as it sounds. You throw your camera into the air, pressing the shutter button at the last possible moment. For results like these you need low light with a source of colored light (I used Christmas-tree lights), and an exposure of around 1/2 sec; the camera will record light trails as it spins through the air. I found that 1/2 sec worked best because that is how long the camera was airborne. When I took these images I was only throwing the camera about 1m (3ft) into the air—it's more about the spin you put on the camera than the altitude you send it to. It goes without saying that this is extremely risky! When I gave it a go I tossed the camera over my bed so that if I did not catch it, it would have a soft(ish) landing.

Camera: Canon EOS 5D [DSLR]
Lens: 50mm
Focal length: 50mm
ISO: 400
Shutter speed: 1/2 sec
Aperture: f/2.8
Accessories: Christmas lights
Light: artificial indoor, low light

↗ Camera tossing gives you light trails that are smoother than those you get with kinetic photography (see page 031) because the motion of the camera spinning through the air is less jerky than its motion with you holding it as you spin.

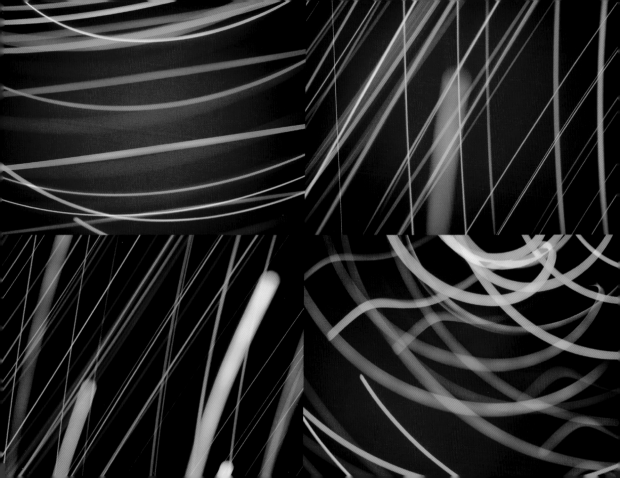

Sunset shots

These shots were actually taken after sunset; if I had taken them into the sun they would have been really blown out, and the contrast levels would be really high. As it is the sky is blown out near the center of the frame, but this is made up for by the reflections of the sky on wet sand. This was one of those perfect occasions—a great sky with the two people and their dog making great silhouettes. I mixed it up a little in this set, shooting some images from the ground (I held the camera just above the sand, as it was wet). Because of the free nature of these shots, and to give the set a more rustic feel, I haven't bothered to straighten the horizon on the wonky ones. I took these shots on a Lomo LC-A and cross-processed the film to increase the color saturation and contrast.

Camera: Lomo LC-A [ZF]
Lens: 32mm
Focal length: 32mm
Film: Agfa Precisa 100, transparency,
 cross-processed
Shutter speed: N/A
Aperture: auto
Accessories: none
Light: sunset

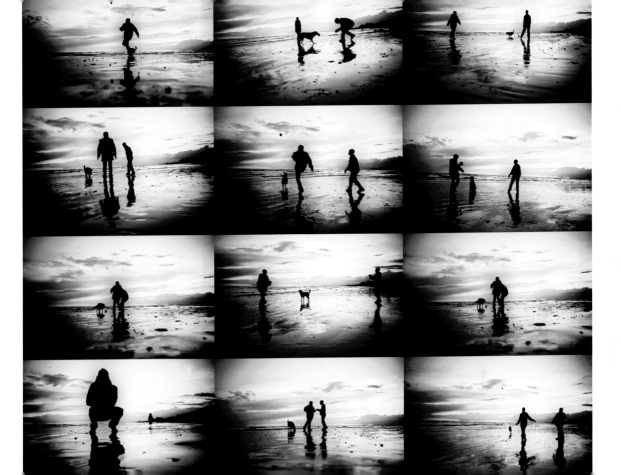

Colored gels and flash

I can't take all the credit for this photo, as Stuart (the model) is the one who set off the flashes. I was shooting on a Lomo LC-A. While the flash normally sits on top of this camera, it doesn't have to. You can get a sync cable to connect your camera's hot shoe (onto which you would normally slide the flash) to a flash, so that you can position the flash away from the camera. For this shot we went a little low-tech. Stuart had a Colorsplash Flash in each hand, and when I pressed the shutter button, he let the flashes off manually. This is only possible in dark conditions where the camera will use a shutter speed over 1/2 sec. I placed a red gel over the flash in Stuart's right hand and a blue gel over the flash in his left.

Camera: Lomo LC-A [ZF]
Lens: 32mm
Focal length: 32mm
Film: Agfa Precisa 100, transparency, cross-processed
Shutter speed: N/A
Aperture: auto
Accessories: Colorsplash Flash × 2
Light: flash

↗ See pages 009 and 111 for other images shot using colored gels and flash.

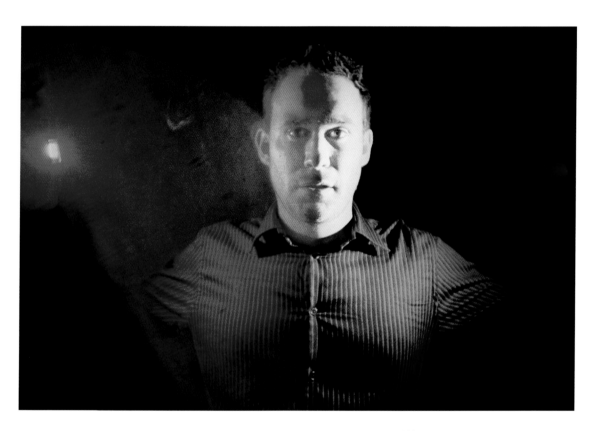

Bad-weather photography

This was taken while I was waiting to cross the Teesside Transporter Bridge in Middlesbrough, UK. I wasn't going to sit in the nice warm car and pass up a photo opportunity. Having a figure in the scene adds a sense of scale that might otherwise not have been obvious—everyone can relate to the size of a human figure. In this image the traffic barriers also give a sense of scale. I was lucky that at the time I took this shot there was a very fine rain. It is this rain that is illuminated by the lights at the far end of the bridge. A foggy night would have given a similar effect, but the wetness of the rain also makes the ground more reflective and, in this case, made the tarmac shine orange. This is another of my images that has got me loving bad weather for shooting in.

Camera: Cosina CX-2 [ZF]
Lens: 35mm
Focal length: 35mm
Film: Fuji Superia 100, negative
Shutter speed: N/A
Aperture: auto
Accessories: none
Light: night, streetlighting

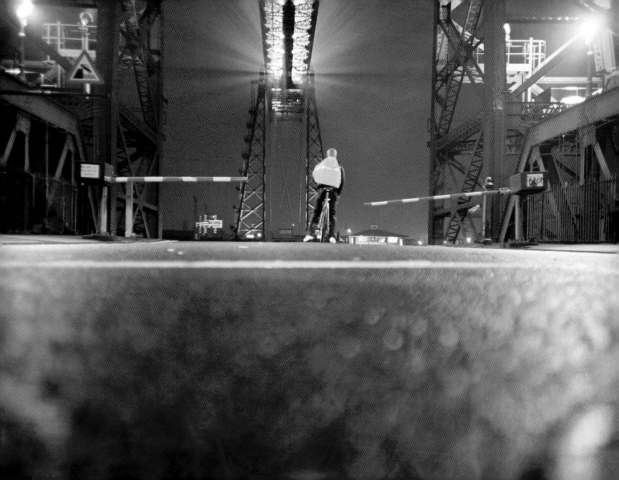

Fill flash motion shot

This shot was taken on a very rainy, dark day at Europe's largest street party—the Notting Hill Carnival in London—where not even the dismal summer weather can dampen people's spirits. Because of the low lighting conditions I was using a flash with my Lomo LC-A for a technique called fill flash. You know you have low light if the right-hand light comes on when you point a Lomo LC-A or Cosina CX-2 at your subject and hold the shutter button down—this means your shot will have motion blur if your subject is moving. What fill flash does is to fire the flash at the end of the exposure so that you get a mix of motion blur and detail. In this shot you can see blurry light trails just to the left of the dancer's dress.

Camera: Lomo LC-A [ZF]
Lens: 32mm
Focal length: 32mm
Film: Agfa Ultra 100, transparency,
 cross-processed
Shutter speed: N/A
Aperture: auto
Accessories: flash
Light: summer, overcast, in the shade

↗ *You can set many digital compacts to fill flash. Check your manual to see if your camera has this feature. You can see a photo for which a similar exposure was used, but with no flash, on page 149.*

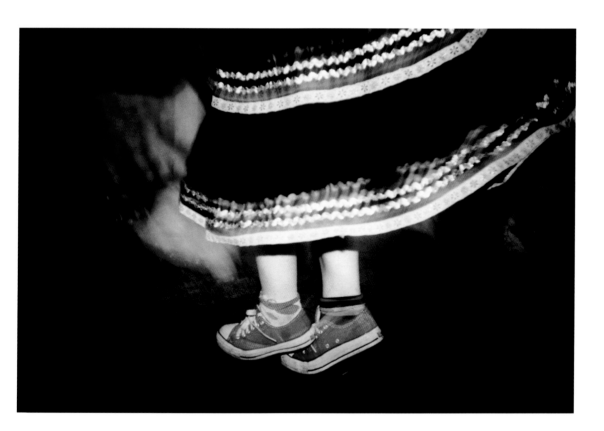

Exposure compensation

With this shot I had to change the exposure level from what the camera thought it needed. The camera took the backlighting into account and tried to get an even exposure in the shot by underexposing the main subject, when clearly I wanted Sarah's face to be perfectly exposed. With most SLRs and DSLRs you can set exposure compensation, which allows you to underexpose (make darker) or overexpose (make lighter) any shot you take. You can also set exposure compensation on the Contax T2, the Nikon 35Ti, and similar cameras; and on some digital compacts. (Check your camera manual for specific instructions.) On zone-focus cameras you can compensate by changing the ISO setting; if you are using a 200 film, set the ISO dial higher (e.g. 400) to underexpose, and lower to overexpose. The most important thing to remember is, if you do set exposure compensation, it will stay set on most cameras until you change it back. Be careful not to leave it set and end up over- or underexposing all your subsequent shots!

Camera: Canon EOS 5D [DSLR]
Lens: 50mm
Focal length: 50mm
ISO: 800
Shutter speed: 1/100 sec
Aperture: f/8
Accessories: none
Light: overcast, backlighting

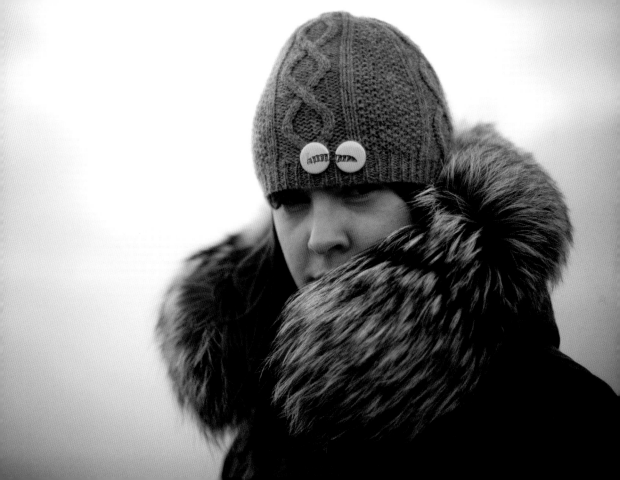

Curious setting

I shot this at the Burning Man Festival in Nevada, where the abnormal is normal (cars with flamethrowers on them, half-naked painted people, etc.) so to see a regular minibus driving through seemed really odd. Even taken out of the context of the festival this image of a bus with "Washoe County Senior Services" written on it driving through a desert seems a little odd. And the oddness of the image gives it a distinct appeal. I found out later that the residents of a local retirement home get a free tour of the festival every year.

Camera: Canon EOS-1 [DSLR]
Lens: 20–35mm
Focal length: 20mm
Film: Agfa Ultra 100, negative
Shutter speed: N/A
Aperture: N/A
Accessories: circular polarizer
Light: bright sun

↗ *I shot this with my 1980s Canon EOS-1. At the time it was what the professionals used. You can easily pick one up for far less than a new digital compact or Lomo LC-A. You have to get a lens as well, but any lens you get will work with any Canon (D)SLR.*

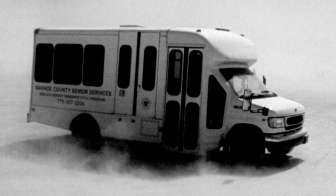

Candlelight trails

This was shot while I was on a *The Third Man* location tour in Vienna, involving 1½ hours in the Vienna sewers. Everyone on the tour is given a candle, which created this photo opportunity. I placed my camera on the ground and held it very steady because any movement in the camera would have meant the tunnel wouldn't be very sharp. I pressed and held the shutter button. The shutter stayed open for as long as it needed to expose the film, which was roughly 30 seconds. The trails you can see are from the flames of people's candles as they passed me. The only illumination in the tunnel was the light from the candles. I blew out my own candle because even if it had been out of shot it would have lit up the ground in front of the camera.

Camera: Cosina CX-2 [ZF]
Lens: 35mm
Focal length: 35mm
Film: Kodak Gold 200, negative
Shutter speed: N/A
Aperture: auto
Accessories: none
Light: dark

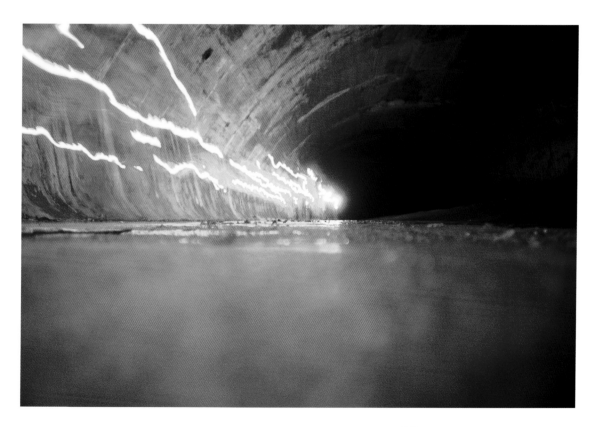

Linear composition

One of my catchphrases is "you should always have a camera on you," and this photo shows why. I have got into the habit of remembering my keys, phone, wallet, and a camera when I leave the house. I noticed the odd scene as I was cycling home one day and asked if it was OK to take a photo. I knew I was going to get a killer shot from the setup, so I took it from many different angles. This image works the best of all the shots because of the strong parallel lines running through it, and also because both Sid and his dog are looking right at the camera. At first I asked Sid just to carry on as normal, but at one point he peered up and I think it really makes the shot.

Camera: Contax T2 [CAF]
Lens: 38mm
Focal length: 38mm
Film: Agfa Ultra 100, negative
Shutter speed: N/A
Aperture: N/A
Accessories: none
Light: afternoon, light shadow

↗ *If someone asks why when you ask if you can take their photo, tell them you think it will make a beautiful image. People are usually flattered by that and say okay. Approaching people can be difficult, but remember, the worst that can happen is that they say no.*

144

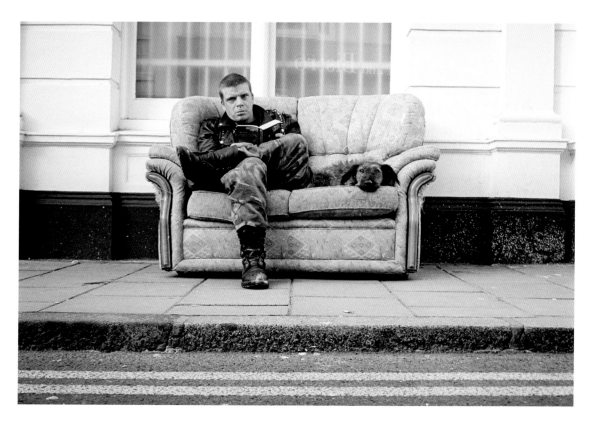

Wedding portrait

When taking someone's portrait it is never a good idea to ask them to look happy or sad because it will never look real, unless you are working with a professional model or actor! I hate smiling when my photo is taken because it always looks like I have a false smile. This was shot at my friend Sangita's wedding. I was taking a couple of informal shots of her while she was chatting to friends when she got all shy and held her flowers to her face. It was a brilliant moment and I snapped it straight away. The flowers covering her face help to create a sense of mystery in the shot. The pink in her clothes and the flowers are really brought to life by cross-processing, and being shot against a dark-green background also helps make the main subject stand out.

Camera: Lomo LC-A [ZF]
Lens: 32mm
Focal length: 32mm
Film: Agfa Precisa 100, transparency,
 cross-processed
Shutter speed: N/A
Aperture: auto
Accessories: none
Light: bright sun, in the shade

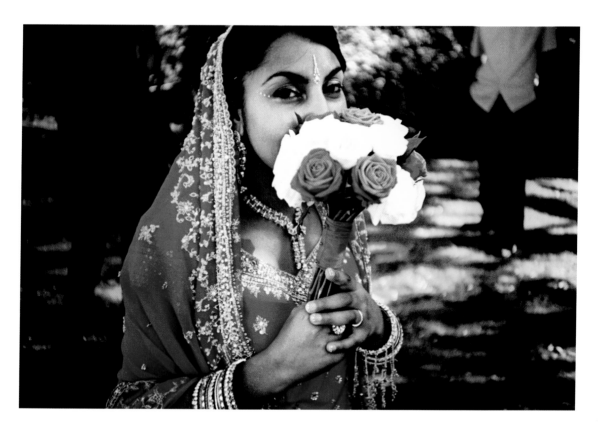

Flash off

This image shows the dreamy effects you can achieve when shooting in dull conditions. Some people have commented that it looks like a boxer who has been knocked out because of what looks like a boxing glove on Dave's left hand, but it is actually a swimmer flinging himself into the sea, backwards. This shot would not have worked so well if the background had been dark because the figure and his movement would be lost in the darkness. If you take this type of shot with a compact camera the flash will try to fire, which will ruin the effect, so you need to turn it off. This mode is sometimes called "forced off." Check your camera manual for instructions on how to do this.

Camera: Lomo LC–A [ZF]
Lens: 32mm
Focal length: 32mm
Film: Fuji Superia 400, negative
Shutter speed: N/A
Aperture: auto
Accessories: none
Light: morning, overcast

↗ There is an example of a similar photo also taken on a Lomo LC-A, but shot against a dark background and using fill flash, on page 137.

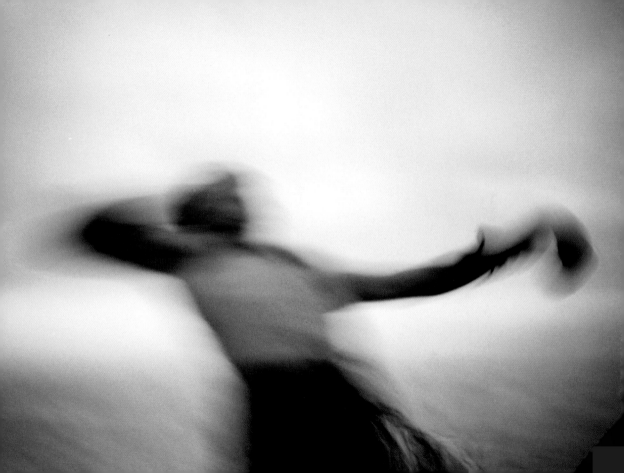

Strong color

This image is all about color. The pink of the boots is really strong against the cold blue tones of the concrete. The image was cross-processed, which is what made the gray concrete appear blue. I have not followed the rule of thirds in this image. The boot on the left is in the middle of the frame, but it is balanced out by the other boot filling out the right-hand side of the frame. I left space in front of the boot because your eye will naturally look to where an object is pointing, in this case to the toe of the boot.

Camera: Lomo LC-A [ZF]
Lens: 32mm
Focal length: 32mm
Film: Agfa Precisa 100, transparency, cross-processed
Shutter speed: N/A
Aperture: auto
Accessories: none
Light: overcast

↗ *I use Agfa Precisa for cross-processing, and it tends to make things appear more blue than they are; that's why it's so great for taking shots that include lots of sky. Other types of transparency film intensify different colors. Experiment to find which you prefer.*

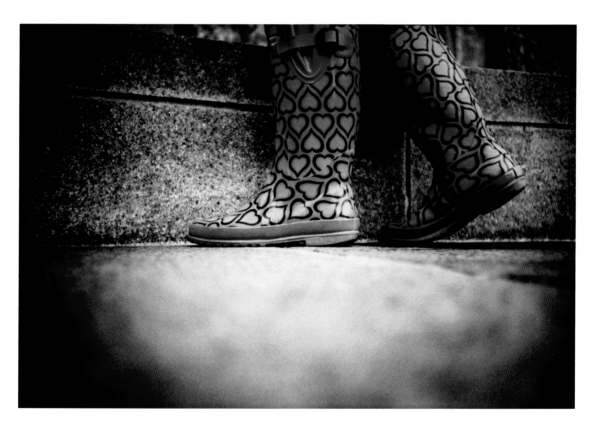

Top-down view

Many photographers get obsessive over something, be that flowers, or house numbers, or ... My obsession is shoes and feet (you may already have noticed this), and the full English breakfast. Whenever I have one, I have to shoot it, and I have built up a nice collection now. For this shot I wanted to get a top-down view of the plate, and because I was using a fixed 50mm lens, I had to stand on a chair to get it. I could have used a wide-angle lens, but the image perspective would have been distorted. As a general rule of thumb, any lens with a focal length of less than 35mm will give a wide-angle view. I would like to point out that I only have a full English breakfast on Saturdays, so you don't need to worry about my health.

Camera: Canon EOS 5D [DSLR]
Lens: 50mm
Focal length: 50mm
ISO: 800
Shutter speed: 1/100 sec
Aperture: f/8
Accessories: none
Light: daylight

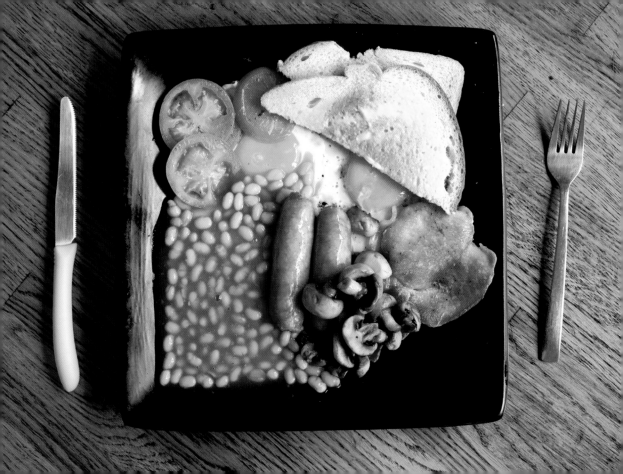

Hidden scale

I made sure I got no people or extra things in this shot of the Holocaust Memorial in Berlin. If the camera had been angled up slightly more you would just be able to see some trees. One of the drawbacks with the Lomo LC-A is that what you see in the viewfinder is not super accurate, so you might gain or lose a little on the edges of your photo. As a rule of thumb, unless you are using the LCD screen on a digital compact, always try to get a little more than you need. In this case I had to crop the very top out in Photoshop. This was shot on an overcast day. If it had been sunny, the tops of the blocks would have appeared white. I can't stress how good it is shooting on an overcast day compared with a bright one. If it's bad weather, don't think it's a bad idea to pick up a camera.

Camera: Lomo LC-A [ZF]
Lens: 32mm
Focal length: 32mm
Film: Agfa Precisa 100, transparency,
 cross-processed
Shutter speed: N/A
Aperture: auto
Accessories: none
Light: overcast

↗ *Other photos for which I have used the hidden-scale technique used here are shown on pages 091 and 175. The Holocaust Memorial is also where the shot on page 021 was taken. From that image you can get an idea of how big these blocks are.*

Holding still

This shot was taken with a slow shutter speed in order to capture the lasers firing across the crowd. At such low speeds, however, you risk camera shake. Ideally, you would use a tripod. You can't set up a tripod in every environment, but you can minimize the risk of camera shake by doing a few simple things. Before you take your shot, take a deep breath and hold it as you press the shutter—the camera won't move with your breath during the exposure. If there is something to lean on, use that to stabilize the camera. I used railings to rest the camera on for this shot. If there is nothing lean on, hold the camera to your face with both hands and rest your elbows against your body so that, effectively, you are a human tripod.

Camera: Canon EOS 50E [SLR]
Lens: 28–105mm
Focal length: 80mm
Film: Kodak Gold 400, negative
Shutter speed: 1/60 sec
Aperture: N/A
Accessories: none
Light: concert lighting

↗ With a digital compact you usually hold the camera away from your face to see the LCD screen. This increases the risk of camera shake. If you have a viewfinder, use that rather than the screen. Turn the screen off if you can, as the glare can be distracting.

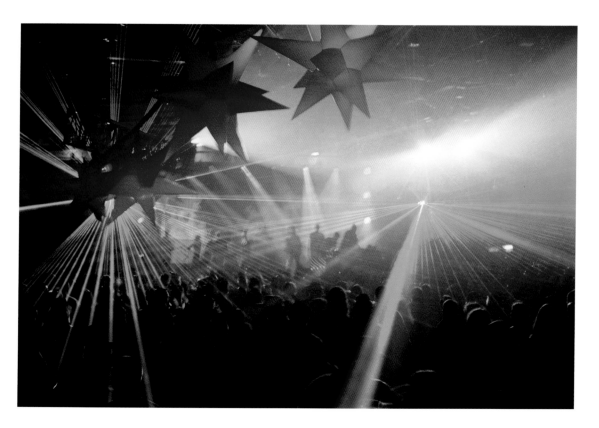

Limited focus

For this shot I wanted a narrow depth of field so that only the figure in the shot would be in sharp focus. Because the camera was loaded with low-rated film (100 ISO) and the light wasn't bright, the camera opened up its aperture to get a good exposure, which gave me just that. I set my Contax T2 to manual focus because with autofocus it will always focus on what's in the middle of the frame.

Camera: Contax T2 [CAF]
Lens: 38mm
Focal length: 38mm
Film: Agfa Ultra 100, negative
Shutter speed: N/A
Aperture: N/A
Accessories: none
Light: natural light through glass

↗ *If you are using a camera that sets the aperture for you and shooting in dull conditions, you will most likely get images with a narrow depth of field, which means there is more chance of subjects being out of focus.*

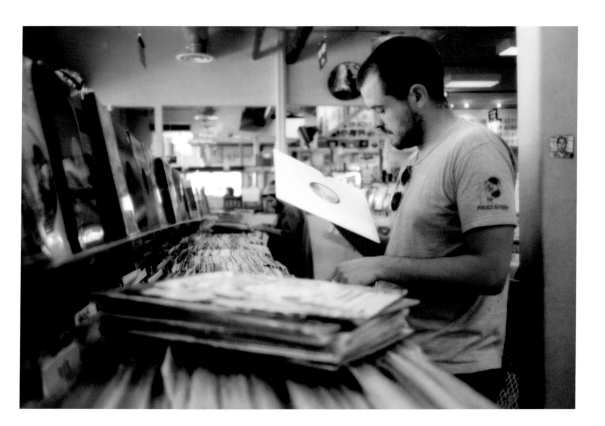

 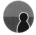

Timed action shot

This shot is all about timing. I wanted to get the streamer at the point where it was closest to me and filled a large part of the frame. I set the distance of the subject from me, held the shutter button halfway down, then waited for the right moment to press it all the way. I positioned the sun behind the girl, but as I moved, a little bit of the sun peeked out from behind her to create a starburst effect. I was pleased with it in this shot, but sometimes it can be an undesirable effect. You can alter the effect by moving slightly so that you see more or less of the sun, but be careful not to stare directly at the sun as it can damage your eyes.

Camera: Lomo LC-A [ZF]
Lens: 32mm
Focal length: 32mm
Film: Fuji Superia 100, negative
Shutter speed: N/A
Aperture: auto
Accessories: none
Light: bright sun

↗ *This type of shot is quite difficult to get on digital cameras because of the delay between you pressing the shutter button and the photo being taken. Take multiple shots in quick succession. If you don't find what you wanted on the LCD screen, try again.*

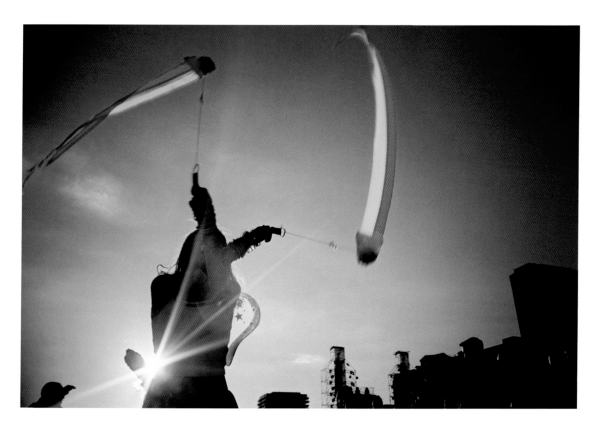

 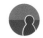

Halation

For this shot I positioned the sun just behind Lee's head. It was so bright it started to burn out the edges of his face, as you can see. This effect is called halation. I placed the camera in the shadow of Lee's head so that when I looked though the viewfinder I would not be looking directly at the sun, and the camera would be in roughly the right place to take the shot. This image is a good example of where breaking the rule of thirds does not matter. The figure is in the middle of the frame, with the lines of perspective (the edges of the path and the shadow) leading to his feet and helping to emphasize him.

Camera: Cosina CX-2 [ZF]
Lens: 35mm
Focal length: 35mm
Film: Agfa Precisa 100, transparency
Shutter speed: N/A
Aperture: auto
Accessories: none
Light: bright sun, backlighting

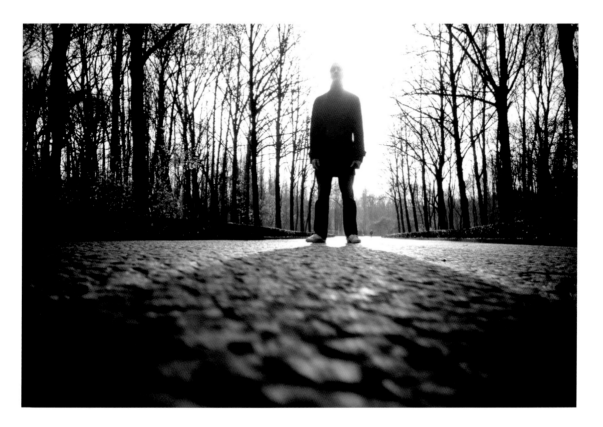

Lines of perspective

The composition in this photo works so well because of the subtle perspective that points to the empty part of the frame on the left. If you imagine one line through the subjects' heads and another through their feet, where those two lines meet would be the picture's vanishing point. Part of the reason I placed the figures on the right-hand side of the frame was so that the vanishing point would not be out of the frame; also, I like to leave space in front of my subjects so there is nothing distracting at the edge of the frame to draw the viewer's gaze out of the photo.

Camera: Cosina CX-2 [ZF]
Lens: 35mm
Focal length: 35mm
Film: Agfa Ultra 100, negative
Shutter speed: N/A
Aperture: auto
Accessories: none
Light: bright sun

↗ You can see a more obvious example of perspective at work on page 043.

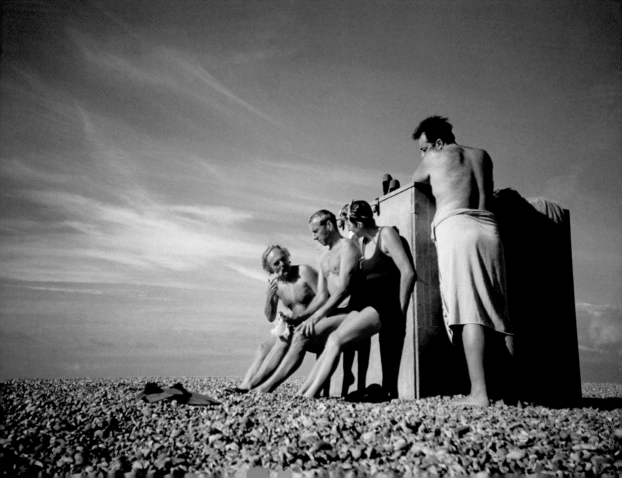

Contrast

When you are visiting somewhere new, try to look out for the small details as well as the more obvious things that you read about in the guidebooks. I was exploring the back alleys of Marrakech in Morocco when I saw a checkers (draughts) set for which the pieces were made up of different-colored bottle tops. The bright blue and red really contrast with each other and jump out at the viewer when compared with the subtle tones in the rest of the shot. The pieces almost look like they are glowing; this is due to my use of the high-saturation film Agfa Ultra. I must confess, I also upped the saturation in Photoshop just a little. (See Color correction on page 202.)

Camera: Lomo LC-A [ZF]
Lens: 32mm
Focal length: 32mm
Film: Agfa Ultra 100, negative
Shutter speed: N/A
Aperture: auto
Accessories: none
Light: afternoon, shade

↗ *Color isn't the only contrast here; there is also contrast between the old checkerboard and its makeshift pieces, and the modern mountain bike in the background. The mountain bike feels really out of place, but it has a very subtle presence because of the focusing.*

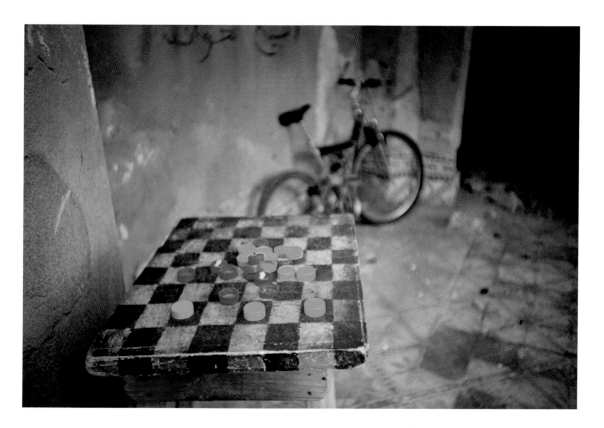

Color adjustment

When I use Photoshop, I don't like it to be too obvious that I have.
In the original shot the bluebells were purple because the image was
developed using cross-processing. Don't get me wrong, I love the
exaggerated colors you get with cross-processing, but I think it's kind
of important that blues are blue, and it is easy to change just one color
in a photo and leave the rest untouched by using the Color Range option
in Photoshop. (See page 202 for how to correct color in Photoshop.)

Camera: Lomo LC-A [ZF]
Lens: 32mm
Focal length: 32mm
Film: Agfa Precisa 100, transparency,
 cross-processed
Shutter speed: N/A
Aperture: auto
Accessories: none
Light: afternoon, shade

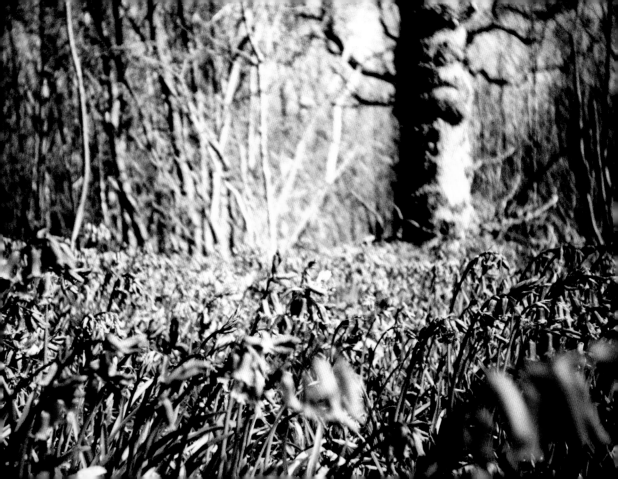

Self-portraits

So, you have been taking photos for a while and as a photographer you need a self-portrait? Why not take one in the mirror with your camera in shot. If you are using a manual-focus camera for which you have to set the distance to the object you are shooting, don't set the distance to the mirror itself—you have to double it to get a decent shot. Don't limit self-portraits to mirrors. Try any reflective surface. You can get all sorts of effects. The bottom-left image was the reflection from a metal surface of the Walt Disney Concert Hall in Los Angeles. Because this surface wasn't a mirror, it added a soft focus to the image. The distortion in the top-right image is the result of shooting into a warped mirror.

All shots except top right/Top right

Camera: Lomo LC-A [ZF]/Contax T2 [CAF]
Lens: 32mm/35mm
Focal length: 32mm/35mm
Film: Agfa Precisa 100, transparency, cross-processed/Agfa Ultra 100, negative
Shutter speed: N/A/N/A
Aperture: auto/N/A
Accessories: none/none
Light (clockwise from top left): natural light through glass/ outdoor light, shade/artificial indoor/artificial indoor

↗ *Another tip—don't be bored in an elevator, get creative. Most elevators have a mirror (see the photo bottom right).*

Grand scale

I wanted to get a grand sense of scale in this shot, which wasn't that hard because it was taken at Europe's largest station—Berlin Hauptbahnhof. I placed the camera on the ground and angled it up slightly because I wanted to show more of the ceiling to give emphasis to the roof. This is not a good idea if it's dark because if you need an exposure of longer than 1/60 sec, you might get a bit of camera shake.

Camera: Lomo LC-A [ZF]
Lens: 32mm
Focal length: 32mm
Film: Agfa Precisa 100, transparency, cross-processed
Shutter speed: N/A
Aperture: auto
Accessories: none
Light: artificial indoor mixed with natural shining through glass

↗ You can see the difference angling the camera makes if you compare this shot with the one on page 043. That photo was also shot at a train station, but the camera base was flat to the ground.

Architectural detail

What I have foremost in mind when photographing buildings is how to simplify the image. Rather than going for a shot of the whole building, I like to strip it back and concentrate on details. This is part of the Walt Disney Concert Hall in Los Angeles. It's worth walking around a building and constantly looking through your viewfinder to see if there are interesting compositions to be made. A full shot of this building would have been really busy, and would have had to include neighboring buildings. This image was shot on Fuji Superia Reala 100, which gives very subtle tones. Even with this low-contrast image the lens vignetting can be seen in the ever-so-slightly darker corners.

Camera: Lomo LC-A [ZF]
Lens: 32mm
Focal length: 32mm
Film: Fuji Superia Reala 100, negative
Shutter speed: N/A
Aperture: auto
Accessories: none
Light: bright day, in shade

↗ To see other shots where I have kept the composition simple and excluded certain elements, look at pages 091 and 155.

Color cast

Although it may not look like it, this was taken during the daytime. There was very low cloud (you can see that the top of the building is obscured by cloud) which made the light very cold/blue. As I have said before, don't let bad weather put you off going out to take pictures—grab your coat and get out there! A digital camera probably wouldn't have captured this scene so well because it would most likely have tried to correct the color with white balance, which would have resulted in the loss of the mood in the picture. In capturing vivid colors, cheap film cameras beat cheap digital cameras hands down.

Camera: Lomo LC-A [ZF]
Lens: 32mm
Focal length: 32mm
Film: Fuji Provia 100, transparency
Shutter speed: N/A
Aperture: auto
Accessories: none
Light: dull and overcast, low cloud

Candid portrait

Sarah and I decided to have fish and chips on the beach despite the adverse conditions, which presented me with a great opportunity for a shot. I often take portraits of people as they are eating: a lot of the time, because they are concentrating on their food, they don't pay so much attention to what you are doing, and they appear more natural as a result. Sarah's smile is in stark contrast with the gray sky and the high winds, which you can see blowing her hood. Her black jacket contrasts well with the light background, and because it also contrasts with her light skin, it really draws your eye to her smile. This photograph means so much to me because it reminds me that Sarah can have fun anywhere, under any circumstances. Sarah and I were friends when I took this shot in 2003, but shortly after this book is published we will be married.

Camera: Lomo LC-A [ZF]
Lens: 32mm
Focal length: 32mm
Film: Agfa Precisa 100, transparency, cross-processed
Shutter speed: N/A
Aperture: auto
Accessories: none
Light: overcast

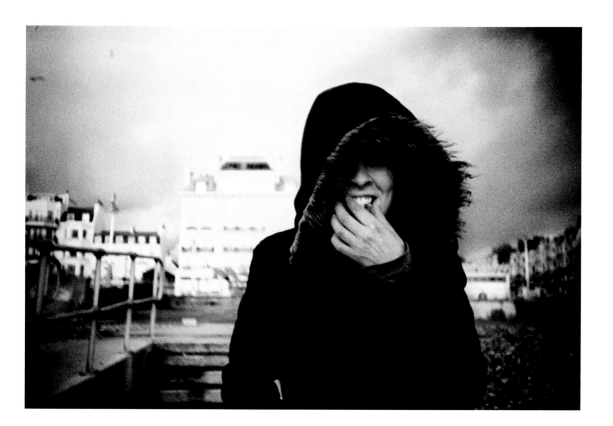

Photography fundamentals

Getting your composition right

Composition can really make or break a photo. If you follow one simple rule—the rule of thirds—this will help strengthen the composition of your photos. This goes against what many people think—that if you are taking a photograph of something, it is best to have that thing slap bang in the middle of the frame. What you need to do is imagine that there is a grid splitting the image into thirds both vertically and horizontally (see image right). Once you have this in your mind, place important parts of your image either on these lines or at points where they intersect. Some digital compacts have the option of displaying such a grid on the LCD screen to help you compose your shots. If your camera has this option, turn it on. In this example, the edge of the swimmer's body is lined up with the first vertical line from the right, and her head is at the point where a horizontal and vertical line cross each other. Composition is all about achieving a balance between the elements of the image, giving more emphasis to some than others. For this image I placed the horizon on the top horizontal line to give the sea more emphasis simply by showing more of it.

That said, rules are there to be broken. I don't really like the word "rule" anyway: I have never been very good at doing what I am told. But it is always a good idea to learn the rules; you need to know how and why they work before you can know when to break them. Most of the photographs in this book conform to the rule of thirds in one way or another, but to see some examples in which I have broken this rule, look at the images on pages 043, 151, and 163. If you are using a camera with autofocus, there is sometimes a technical drawback in trying to follow the rule of thirds: even when your subject is not in the center, some cameras set to autofocus will try to focus on what is in the middle of the frame. But there is a way around this, as explained on page 012.

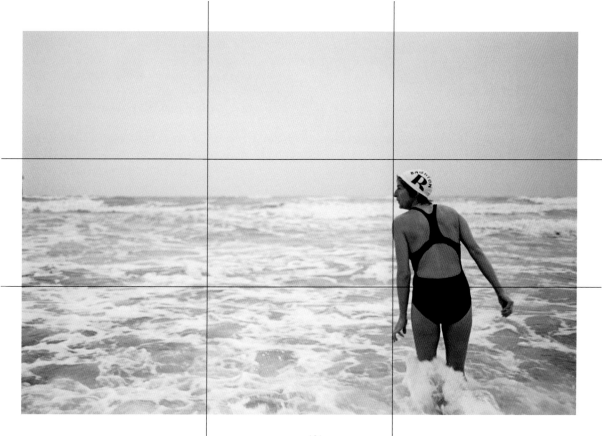

Getting the right exposure

Once you have chosen the composition of a photograph you, or your camera, will have to select the exposure. Exposure is something I mention a lot in this book. This subject can be a bit technical, but today's cameras are designed so that most of the time you don't need to understand all the ins and outs. I think it helps to have some idea of what is happening inside your camera though, even when it is set to fully automatic. In a camera you either have film or a digital sensor. These are what actually record the photographic image. Exposure refers to the amount of light reaching the film or sensor. If too much light reaches the film/sensor, the shot will be OVERexposed, with the result that parts, if not all, of the image will be too bright. If too little light reaches the film/sensor, the shot will be UNDERexposed and the image will be too dark. The idea is to get just the right amount of light onto the film/sensor. This is achieved through a balance of two things: shutter speed and aperture. Shutter speed refers to the amount of time that the film/sensor is exposed to light. Measured in fractions of a second, it is represented as 1/60, 1/125, etc. (See page 184 for more on shutter speed.)

The aperture setting on your camera regulates the amount of light that reaches the film/sensor. This is controlled by a hole, or aperture, that sits between the lens and the film/sensor, and which can be made larger or smaller so as to allow a different quantity of light to reach the film/sensor. Aperture is measured in f-stops and is represented as f/4, f/22, etc. The higher the number, the smaller the hole will be, thus reducing the amount of light that will reach the film/sensor. (See page 186 for a detailed explanation of aperture.) Not all cameras allow you control over both aperture and shutter speed; some allow you control only over the aperture setting.

When you change either setting, shutter speed or aperture, up or down one notch, you are effectively halving or doubling the amount of light that reaches the film/sensor. Because of this, if you increase the shutter speed you also have to increase the aperture in order to compensate for the resultant reduction in light, and vice versa. It is basically a balancing act. In this image, while some viewers might feel that the stones are too bright, for me it was worth it to get that dramatic sky.

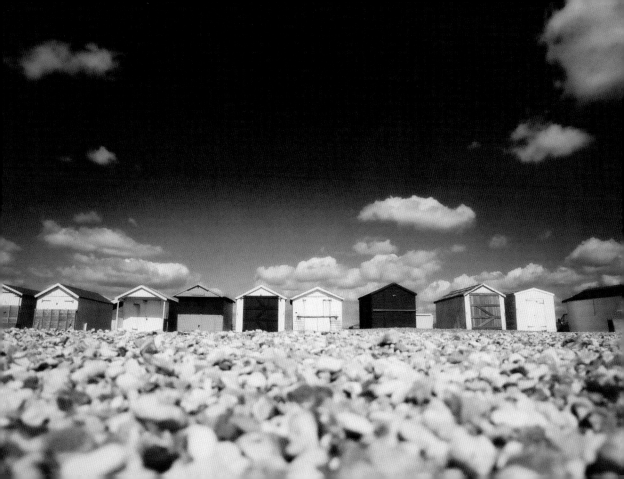

Shutter speed

Shutter speed controls how long the film/sensor is exposed to light. If you use a very fast shutter speed, moving objects will appear to be frozen in time; if you use a slow shutter speed, any moving objects will appear blurred. As you can see in this image (below left), the train appears blurred, but the feet, which were still, are sharp. If you are using fast shutter speeds you generally need brighter lighting conditions, because the faster the shutter speed, the less the amount of light that will reach the film/sensor.

Once your shutter setting drops below a certain speed you need to use a tripod; if you don't you will get camera shake. This is caused by the camera moving while the shutter is still open, and the effect is a general blur over the whole image. Most of the time this is undesirable. To work out if your shot is at risk of camera shake you need to know what focal length your camera is set to; that is, how zoomed in you are. With a focal length of 60mm you can get away with 1/60 sec; if your lens is 30mm you can get away with 1/30 sec. The higher the focal length (the more zoomed

in you are), the faster the shutter speed you will need in order to avoid camera shake. Some cameras have an "antishake" feature to cancel out the effect of camera shake. The image left was shot at around 1/30 sec; during the time the shutter was open, the train in the picture moved, which is why it appears blurred. This is called motion blur. Some good examples of what can be done using long shutter speeds are shown on page 031. If you are taking a shot and shutter speed is important for the subject you are shooting—you want your subject to be either motion blurred or frozen in time—you can set your camera to shutter-speed priority. (This is labeled TV on Canon cameras and S on Nikon cameras; always check your camera manual to find how the priority settings are labeled). This allows you to set the desired shutter speed, leaving the camera to set the aperture required to achieve a good exposure level. With cameras such as the Lomo LC-A and Cosina CX-2 (see page 192), you have no control over shutter speed.

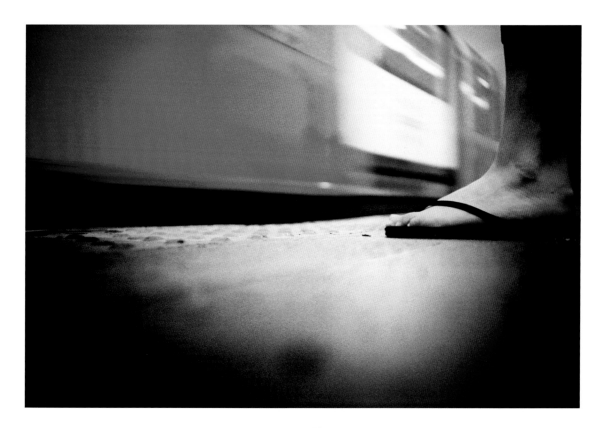

Aperture and its good friend, depth of field

The aperture controls the amount of light that can reach the film/sensor. The aperture, or hole, that lies between the lens and the film/sensor can be made larger or smaller so as to allow different amounts of light to reach the film/sensor. The simplest way to visualize the aperture is to think of it as the camera's pupil. If you are outside on a bright day, your pupils will get smaller to stop too much light reaching the back of your eye; similarly, when it is dark your pupils will dilate to allow more light to reach it. The aperture setting refers to the size of the hole. This is measured in f-stops, which are represented as f/2.8, f/4, f/5.6, f/8, f/11, f/16, etc. The higher the number, the smaller the hole, and the less the amount of light that reaches the film/sensor. Each step up on the scale halves the amount of light hitting the film/sensor, so f/2.8 will allow twice as much light as f/4.

This confuses a lot of people: they don't understand why a bigger number means less light. It means less light because the f in the f-number represents the focal length of the lens being used. Focal length, measured in millimeters, refers to the magnification a lens is capable of; the higher the measure, the greater the magnification the lens will give. So, if you are using a 100mm lens with an f-stop of 2.8, the diameter of your aperture will be 100 divided by 2.8, which is 41.6mm. If you have your aperture set to f/4 using the same lens, the diameter will be 100 divided by 4, which is 25mm—a smaller hole allowing in less light.

Aperture affects something called depth of field (often abbreviated to DOF). Depth of field is used to control how much of the image is in focus. In the photograph

right you can see that the girl is in focus, but that everything behind her is out of focus, and the object closest to the camera—the railing the girl is sitting on—is out of focus too. This is because the camera was set to f/1.4 and therefore the aperture was at its largest; a lower f number (bigger aperture) gives you a shorter depth of field, making less of an image sharp.

The effect of a short, or shallow, depth of field is particularly useful for highlighting one part of an image, as the girl has been highlighted here. If I had shot this photo on f/22, practically everything in the image would have been in focus, including the bunch of people on the right, and they would distract the viewer from the main subject in the photo—the girl on the phone.

If the depth of field in a particular shot is important to you, you can set your camera to aperture priority on most SLRs and DSLRs, and on some compact cameras. This means you can set the desired aperture and the camera will set the appropriate shutter speed to get the right exposure. One thing to note is that if your camera has an aperture priority mode, it probably won't be

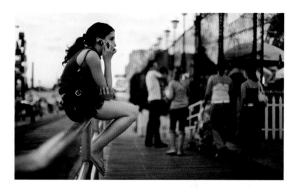

labeled "aperture priority" on the camera. On Canon cameras, for example, it is labeled AV whereas on Nikon cameras it is A. Check your camera manual to find out how each feature is labeled on your camera.

Put simply, with f-numbers and apertures:

- A low f-number means a big aperture, which gives a narrow depth of field, meaning less of the image will be in focus.
- A high f-number means a small aperture, which gives a long depth of field, meaning more of the image will be in focus.

Types of cameras

When it comes to cameras, I use four different types, and in this book I refer to five:

- digital compacts [DC];
- single-lens reflex [SLR] and
 digital single-lens reflex [DSLR];
- basic film compact, zone focus [ZF];
- film compact, autofocus [CAF]; and
- Nikonos-V [NiV].

Digital compacts

I don't own any compact digital cameras (I own enough cameras as it is!), but a lot of what I write about in this book is relevant for people shooting with this type of camera. Many people think that the megapixel rating is the most important feature to look for when buying a digital camera (the more the better), but the industry has reached the point at which most cameras have a rating above 7 megapixels, which means you can print high-quality photos at A4 (210 × 297mm/ 8⅛ × 11⅝in) size, and even double that, and still have

prints of an acceptable quality. I would say one of the most important things to look for in a new digital camera is how it handles low-light situations without flash. You should also look for a model with as little shutter lag as possible. (This is the delay between you pressing the button to take a shot and the shot being taken.) Finally, it is very important to look for a camera that allows you control over shutter speed and aperture if you want to get creative.

An indispensable tool when buying a new camera is flickr's camera finder feature (www.flickr.com/cameras). With this part of the flickr site you can search for any type of digital camera to see the kinds of pictures that have been taken with it—holding a camera in the store is one thing, but seeing what it is capable of is another.

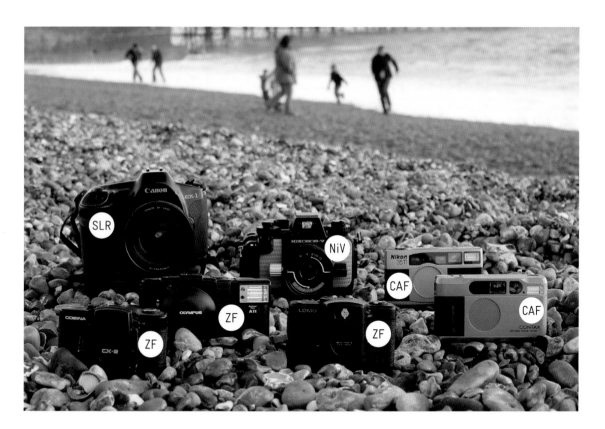

SLRs and DSLRs

The second type of camera is the SLR, including DSLRs. SLRs use film to record the image, whereas DSLRs use a digital sensor. Both work in the same way, apart from the fact that you can't review the image after you have shot it on an SLR, so what I say below refers to both. When you look through the viewfinder of an SLR, you are looking through the same lens that the picture will be taken through. On an SLR you can have complete control over aperture and shutter speed and, therefore, complete control over how your shot will come out. Also, lenses are interchangeable between SLRs of the same make. Because both my SLRs are Canon, I can swap the lenses between them. However, if, in the future, I wanted to use Nikon gear, I would have to change all my lenses. Because of this most people choose an SLR brand and stick to it. There are endless discussions about which brand is better, but to be honest, I really don't think there is anything between them. I've been using Canon SLRs since 1995, but I'm sure that if I had started with Nikon back then, I would still be using Nikon now.

The drawback with SLRs is that they are bulky and not convenient to have with you at all times. The cameras of this type that I use are the Canon EOS 5D, Canon Rebel (EOS 300D), and Canon EOS-1. My advice for buying an SLR is to spend money on a good lens, and prioritize that over the body. The most important part of a camera is the lens: the lens is what makes the image sharp, what controls the depth of field in an image. If your camera has a poor-quality lens, there isn't a lot the camera body can do to do fix it. The professional photographers I know keep their lenses for years, but often upgrade their camera bodies.

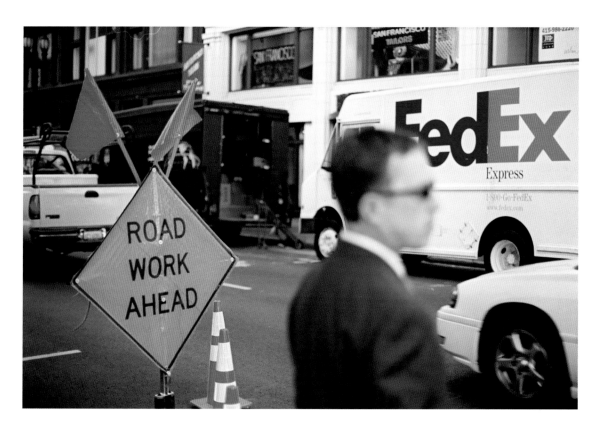

Basic film compacts, zone focus

The third type of camera is the older-style film compact camera with a zone focus. The models I use have the unique feature that if, in dark conditions, you press and hold the shutter button, the shutter will stay open for as long as it needs in order to get the correct exposure. With no autofocus feature, you "focus" by setting the distance between you and your subject; you cannot see whether the subject is in focus just by looking through the viewfinder. That may seem like a disadvantage, but it does mean that you don't have to wait for autofocus to work as you do with autofocus cameras. With some autofocus cameras, if they can't focus on a subject there can be a very long delay between you pressing the shutter button and the photo being taken. With old-school cameras, as soon as you press the shutter button the shot is taken, even if it is going to be a bit blurry!

Another advantage with this type of camera is that you can get hold of most models very cheaply second-hand. On top of that, because they look so retro, most people don't take them seriously. It is surprising to see the different reaction you will get from people if you take their portrait with a cheap-looking plastic camera as opposed to a more professional-looking DSLR—people tend to relax more.

The cameras I use of this type are:

• Lomo LC-A;
• Lomo LC-A+;
• Cosina CX-2; and
• Olympus XA-2.

There are many more, including Chinon Bellami and the cameras from the Minox 35 series. My advice, if you want to buy these cameras, is to look on eBay and see which models are the cheapest. Their price goes up and down depending on demand. I have seen some models go from $50 to $175 and back, so it is best to be patient. Of all these cameras the Lomo LC-A+ is the only one still being manufactured.

Throughout this book, any techniques I mention in relation to the Lomo LC-A or the Cosina CX-2 apply equally to the other zone-focus cameras listed here.

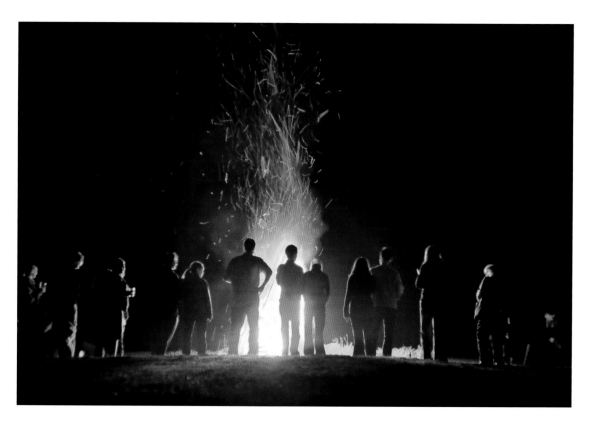

Film compacts, autofocus

The fourth type of camera is the autofocus compact film camera. These cameras are no longer manufactured so you have to pick them up secondhand. You can pay relatively small amounts of money to get a camera that can take fantastic-quality photographs. Compact film cameras have the advantage of being small so you can have one on you at all times. Also, most have a built-in flash so you can light up any dark subjects if necessary. The cameras I use of this type are the Contax T2 and Nikon 35Ti. There are many more, too many to list here, but a few among the models I know are the Contax T3, Yashica T4, Leica Minilux, Ricoh GR1, and Minolta TC-1. All these cameras were designed during the late 1990s when camera manufacturers were trying to outdo each other by designing the best-quality compact film camera, and money was no object. Today you can pick them up on eBay for a fraction of the original retail price. These cameras were renowned as the models a professional photographer would carry at all times.

The reason the professionals used them was down to the lens they had inside—they were always of the highest quality. As well as having an autofocus setting, they give you the option of focusing manually.

Techniques mentioned in relation to the Contax T2 and Nikon 35Ti apply equally to other film compact, autofocus cameras listed above.

A note on the lens

These were shot on my Contax T2 and show just how sharp and crisp images from the T2 can be. This is down to the Carl Zeiss lens the T2 uses. Carl Zeiss is known for the exceptional quality of its lenses. It makes lenses for many different camera manufacturers, so if you are shopping for a new digital compact, look out for models that have a lens made by Carl Zeiss. They might be a little more pricey, but they will be worth it.

Another brand of lens to look out for is Leica. Though Leica is better known for its high-quality M System cameras (the first practical 35mm handheld cameras), Leica lenses now appear on digital compact cameras.

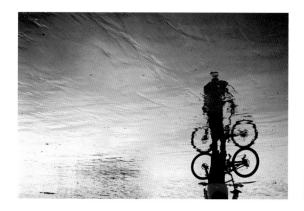

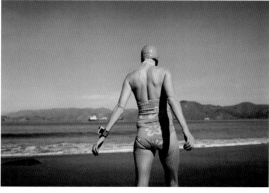

Film and processing

Types of film

I use a lot of Agfa Ultra and Precisa. Unfortunately, Agfa no longer makes film, so I now use Kodak PORTRA 400VC (vivid color). One of the drawbacks of Agfa Ultra is that, because of its high color saturation, skin tones come out a red/pink; if you are taking photos of people exercising, or who are hot, they can appear very red in the face. This can be made even worse with flash. With Kodak PORTRA this is not the case. One of the benefits of PORTRA is the subtle skin tones it gives. You should use this film if you plan to shoot a lot of portraits. Fuji Reala gives very similar results to PORTRA, but it doesn't reproduce skin tones quite so well.

If you buy film in bulk you should really keep it in a fridge because it does go off, if only very slowly. Bulk buying is a good idea because you can pick up great films for as little as US $2 a roll. Sites such as eBay are great places to buy film in bulk: shops tend to sell off stocks that are close to their sell-by date.

Film speed

If you shoot on film, one thing to consider when choosing your film is film speed. Film speeds are given in terms of ISO ratings—the higher the ISO, the more sensitive to light the film will be. If you are shooting on a sunny day, use a 100 ISO film, but if it is winter and overcast, go to a 400 ISO. Color films are available in ratings of up to 1600 ISO, but there is a trade-off with such high-ISO-rated films—the images they produce are very grainy (referred to as "noise" in digital photos), and the colors are not as vibrant as lower-rated films. For this reason I don't use color films with speeds over 400 ISO; if I do need a higher rating, I use black-and-white film. You can see an example of a super-grainy black-and-white shot on page 019. Basically, the lower the ISO, the higher the quality of the image.

With digital cameras you can select the light sensitivity of the sensor. This is referred to in terms of ISO ratings just like film, and just like film you get a higher-quality image with lower (less sensitive) ISO ratings.

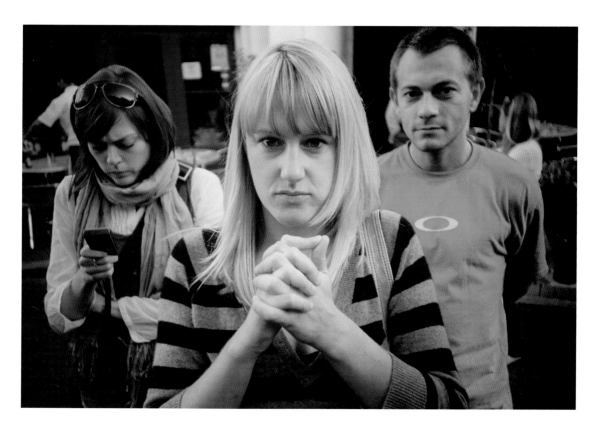

A little help from cross-processing

One of the things about my photography that people always comment on is the color. The strong color I get is mainly down to the fact that I tend to use film rather than digital cameras, but there is a little more to my film photography than meets the eye.

A lot of the time I use a film-processing technique called cross-processing to increase the contrast and saturation in an image. (Saturation describes the amount of color in a picture; if a picture is black-and-white it has no saturation.) There are two types of film: print film (negative) and transparency or slide film (positive). The chemicals the lab will use to develop your film depends upon whether you have used negative or transparency film: C-41 is used for negative, and E-6 for transparency. This is where the "cross" comes in: for cross-processed shots I shoot on transparency film, but get it processed in C-41,

so instead of slides I get very dense negatives with a high level of contrast and saturation, and from which prints can be made. I think the reason people find cross-processed photos so appealing is that they present them with something they are not used to seeing, something different from the super-realistic colors that a lot of photographers try to achieve.

Travel with a portfolio

I was swimming with friends at China Beach in San Francisco and one of the people in the group was doing some yoga moves, warming up for her swim. (I did not know Jennifer at the time.) I asked if it was OK to take her photo, and she said yes. After the swim I was able to show her what I do because I always carry some photos on me: people are more willing to let you take their photo if you show them what you do. I used to carry a mini photo album filled with 6 × 4in images, about 160, but as I carried it everywhere, the plastic covering the photos got scratched and it started to look a bit worse for wear! Now I have a set of photos on my phone. The advantage of this is that, if you are like me, you will take your phone everywhere. In my opinion the cameras on phones are pretty bad, but if you load photos onto your phone they usually look really good on a backlit screen. Obviously the bigger the screen, the better the image quality, so this will depend on what phone you have.

Alternatively you could use an iPod; most iPods have the ability to store photos. You can buy dedicated photo viewers as well, but for the money you pay, you might as well get an iPod Touch with a 3 × 2in screen or a PlayStation Portable. While I was looking at the prices of mini photo viewers I spotted a keyring photo viewer for US $30, so there really is no excuse for not taking some photos on the road!

Super-sharp scanning

One of the questions I get asked all the time is what scanner I use to make my negatives and transparencies look so crisp. I don't. I would only recommend getting your own negative scanner if you already have a large number of films that need scanning. I get my negatives scanned at the photo lab at the same time as I get the film developed because it costs roughly the same as getting prints made. I no longer get prints made because I would run out of places to store them! To save money I get them scanned at a low resolution (1,500 × 1,000 pixels). This is fine for standard 6 × 4in prints, posting on the Internet, and e-mailing. If I need an image at a higher resolution, for publication or to make a big print for example, I will go back and get that negative rescanned. The trouble comes when you want to get cross-processed films scanned: some labs have no idea what they are doing when it comes to cross-processing.

If you can't find a decent lab in your local area, some labs offer a postal service. US Color Lab, a great lab in New York City, does just that. The best way to get an idea of what particular labs are like is to ask the people who use them. What you can do is join a user group (see page 210) related to the town in which the lab is located and ask the other users if they know that lab, and how they like it. When I travel I always get my film developed on the road, and this is how I find the best labs.

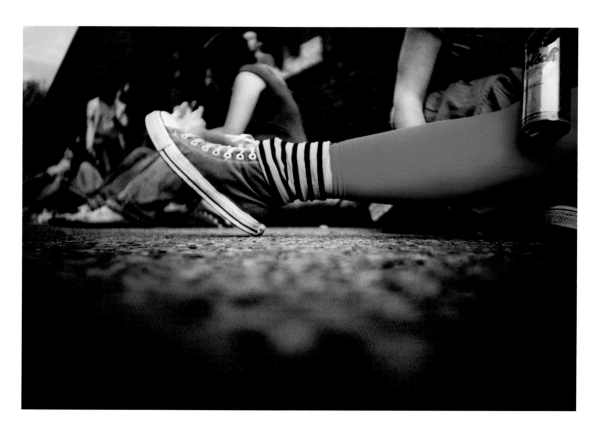

Photoshop essentials

Color correction

Photoshop is not a massive part of my work. For some photographers taking the photograph is just the start of a photo, but I use the software in a very limited sense. There are three things that I commonly do to an image:

• correct the color;
• crop and straighten the image; and
• remove any dust and scratches.

In this example you can see that the original scan is just a bit too green, but that is easily fixed using Variations. In Photoshop go to Image > Adjustments > Variations... A window showing different variations of your image will open. The top two images are the original version (a) and that of your new changed version (b). At the start of the process they will both be the same. The image with six variations around it (c) shows you what your image looks like now, surrounded by six different color variations. Clockwise from top left, these variations show what the image would look like with more green, yellow, red, magenta, blue, or cyan added. You can click on these variations to add that color to your image.

You can turn the amount of color up or down by moving the slider between Fine and Coarse (d). In this case, because my image was too green, I looked to the variation opposite the green image, which is magenta. If your photo has people in it, it's best to try and get skin tones looking natural. Once you have done that, other things in the image that are not quite the correct color don't stand out as much. You can also darken and lighten the image by clicking on the top and bottom images in the Lighter/Darker section (e). By default, when you first open Variations it is set so that you are changing the midtones of the image. You can make changes to the highlights and shadows by clicking on these options, in the top right-hand section of the

Less Saturation | Current Pick | More Saturation

window (f), but I usually find I only have to make changes to the midtones. Sometimes I like to bump up the saturation. This is done in the same way as adding more of a particular color: you simply have to click on Saturation (f). If at any point you feel you have gone too far you can revert back to the original by clicking on the Original thumbnail (a) and starting again. Once you are happy with your image, simply click OK and you will be back in the main Photoshop environment with your updated document.

Cropping and straightening

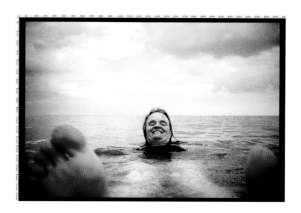

There is nothing more distracting than having an image with a wonky horizon. I'm not saying its wrong to have a wonky horizon in a photo, but if you intended it to be straight and it's out by a few degrees, it is very noticeable. Luckily it is also very easy to fix with Photoshop. Select the Crop Tool from the Tools palette or press "C," then click on the top-left corner and drag the mouse to the bottom-right corner, then release the mouse. You should see a moving selection line running around the edge of the image; this is called a marquee selection. Rotate the marquee to match the angle of the horizon. To do this you need to be in Full Screen Mode. Enter Full Screen Mode by pressing "F." By default the marquee's center of rotation is the middle of the marquee. You can move the center point around which the marquee rotates by dragging the target at the center of the marquee. In this case I have moved the center point to the bottom-left corner (a), resting on the horizon to make it easier to see when the horizon is lined up. Click and drag the selection so that the corner you have just dragged the rotation point to is lined up with the horizon (b). If your image doesn't

have a defined horizon, you can use a building or other objects you know to be horizontal as a guide to the angle at which the horizon should be set. If you now click and drag outside the marquee it will rotate the selected area. Rotate the area so that this crop selection is in line with the horizon (c). Now that you have the crop selection at the same angle as the horizon, move the selection area so that the bottom corner lines up with the bottom of the picture by dragging it (d). Because the crop marquee is at an angle, it will extend beyond the image. Click on the corner that is outside the image and drag until it is inside the image (e). If you hold down the shift key while you drag, it will maintain the aspect ratio of your original selection. I always maintain the aspect ratio of the 35mm image because this keeps all my

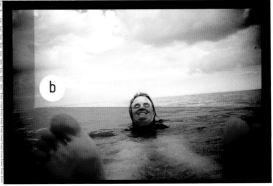

photos the same size, and is better for getting standard photographic prints. You can move your selection left and right so as not to lose parts of the image that are important to you. In this case I wanted to keep all the toes on the left foot and had to opt to keep only the big toe on the right foot. A tough decision, but these things have to be done. Once you are happy with your crop, hit enter and the image will be cropped.

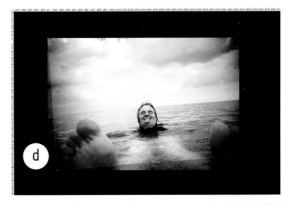

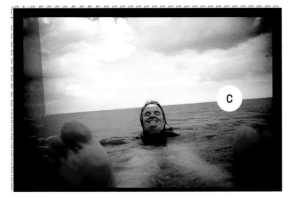

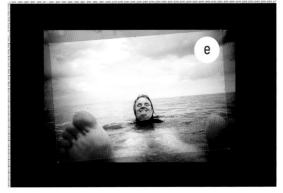

Removing dust and scratches

There is nothing worse than paying out for a 20 × 27in print and then finding there is a nice big piece of dust in the middle of it. I have only done that once and it will never happen again! You don't really get dust and scratches with digital photos, unless your camera's image sensor is dirty, but film is a different story. The negative can get scratched inside the camera, and while the photo lab should take every precaution with your negatives, dust does have a habit of getting into the mix. But recent versions of Photoshop make dealing with dust a piece of cake. By using a Filter you can remove dust and scratches with a few clicks of the mouse, but it's not as magical as it sounds because it can have undesirable effects on the rest of the image. For the sake of a few minutes, it's not really worth being lazy. To best see the dust you are going to bust you will need to set the document view to 100%. Go to View > Actual Pixels or press alt + control + 0 (Windows)/alt + apple + 0 (Mac). Open the Navigator palette by going to Window > Navigator (a). You will notice there is a red box (b) in the Navigator palette that highlights the area you are looking at in the main window; if you

drag this red box around, you will change what you see in the main window. In this way you can easily move around the document looking for dust and scratches. Select the Spot Healing Brush Tool from the Tools palette (c). All you have to do when you find a piece of dust is simply draw over it with this tool and it will magically disappear, no matter what the color/texture behind the piece of dust is. You can change the brush size of the Spot Healing Brush Tool by clicking in the Options palette on Brush (d).

Online photo sharing

When most people take a photo they are proud of, they want it to be seen by a wider audience. A great way to do this is to show your work online on one of the many photo-sharing services. Shutterfly.com, snapfish.com, and kodakgallery.com are aimed at users who want their photos to remain private unless they specify otherwise. These sites have their own printing facilities, so with one click you can order prints and other printed items including mouse pads and mugs. These sites are free—they make their money when you order prints. Sites such as smugmug.com, ipernity.com, flickr.com, and deviantart.com are aimed at people who want the world to see their photos.

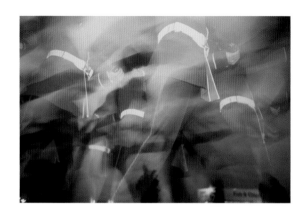

Smugmug.com has a paid-for service, which it calls prozone, that allows you to remove its logo from your smugmug pages so it looks like your own personal photography site. It also gives you the option to sell your prints through the site. Deviantart.com is not just aimed at photographers; if you join this site you will be rubbing shoulders with illustrators, filmmakers, and painters. Both ipernity.com and flickr.com have very

clean and easy-to-navigate interfaces that make it easy to jump around the site from user to user. They also offer a wide range of features that make it easy to search for and find particular photos. Ipernity.com is totally free while flickr.com offers a paid-for pro account. Neither site carries advertising on the photo pages.

I use Flickr because it offers many more features than any of the rest. Flickr is more than a place to store your photos online—it allows you to organize your collection in various ways through the use of tags, and that allows

people to search for the particular subjects that they are interested in. I tagged the photo left with "people, guards, marching, etc." You can also organize your photos in sets. This photo belongs to my "London" set because that's where it was taken. If I want to show someone the photos I have taken of London I simply e-mail them the link for my London set, which saves me the trouble of trying to e-mail lots of photos. Flickr also gives you the option of placing your photos on a world map to show people where you took them.

There is a social aspect to photo-sharing services as well: through Flickr I have become great friends with a lot of people, from all over the world, whom I would not otherwise have met.

A great way to further your knowledge of photography is to join one of the many groups on Flickr. Users can create groups devoted to any subject. I took the photo right with a Lomo LC-A. If you want to find out more about that camera you can join the "Lomo LC-A" group and post your questions on their forum. With member numbers in the millions, there is a group for just about everything.

The list of Flickr's features is almost endless; I could easily write a whole book on the subject. If you are reading this book then you clearly have an interest in photography—go take a look at Flickr. You will be amazed at how easy it is to spend several hours browsing through great photos. My username is lomokev on flickr.com—come and check me out.

What next?

So, you've got loads of images and you want to make something of them. Making prints is an obvious option, but that's so '90s. There are many companies out there waiting to receive your photos to make something other than just prints of them. First up is www.moo.com. MOO makes stationery from your photos, but not the usual stuff you find in an office. They have a wide range of products that includes mini cards that are like business cards, greeting cards, postcards, sticker books, and more. All of the images printed on the cards on the right are from moo.com. The great thing about MOO is that you can upload 90 images and get 90 individual stickers, or upload two images and get 45 stickers of each. And that's the same with any of the products. Images can be uploaded from your computer or from flickr.com, facebook.com, bebo.com, and many other sites.

If you want to make a book of your photos, and when I say book I don't mean a photo album, I mean a book complete with cover and text, a couple of sites I would recommend are qoop.com and blurb.com.

Printing and framing is covered by imagekind.com. Send them your digital files and they will print your image at any size between 6 × 4in and 16 × 11in, then mount and frame it in the style you select—and the quality is as good as any professional framing I have seen. All of these websites will grab Flickr photos, so if you have a Flickr account you don't need to re-upload your image to the web in order to start printing some great stuff. With imagekind you can only upload images from Flickr or your computer.

Image management

Filing your photos

If you don't keep your work organized, you need to start organizing now, especially if you are shooting on film. I am constantly amazed by friends who keep their negatives in a shoebox. What if someone sees one of their shots on Flickr or somewhere else and wants to use it in a publication, or wants a print? They'll need to dig out that negative, and it's not much fun holding up endless negative sheets to the light to find one shot. Trust me, I've been there! I am not one of the world's most tidy people, but I do keep my negatives super organized. If I needed to find the negative of any one of my shots, I could find it in minutes.

Every time I get a film processed I get it scanned to CD by the photo lab. When I get home I label the negative sheet, index card, and CD with a unique name consisting of the date and the camera the film was taken on, for example 2009-04-30-lomo-lca. If I have more than one roll developed that day I add a, b, c, and so on to the end, so the first roll will be 2009-04-30-lomo-lca-a,

the second 2009-04-30-lomo-lca-b, and so on. I then file the negatives, index print, and CD for easy retrieval. You must also deal with your digital assets. I copy all the image files to my computer into a folder called 2009-04-30-lomo-lca. Once your image files are on your computer, you need to change their file names. By default, file names on a CD will be named something like CNV001.jpg, CNV002.jpg, etc. I find and replace the "CNV0" part of the file name with "2009-04-30-lomo-lca-" so my files are called 2009-04-30-lomo-lca-01.jpg, 2009-04-30-lomo-lca-02.jpg, etc.

There are a number of simple, free applications that will do this for you, and they can save you a lot of time. On the Windows operating system select all the files you want to rename by pressing ctrl + A, then press F2 to rename the files, type in the new name, and press Enter. All the files will be renamed with a unique number appended to each one. For the Mac operating system I would recommend Filelist from www.manytricks.com. If you put any of your photos online, tag them with the file name you have used. That way, if you need to, you can easily find the image file and/or negative.

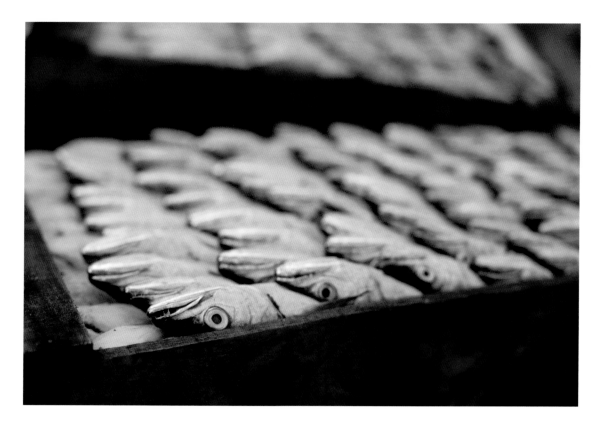

File backups

Whether you are taking photos for fun, for school, for family history, or to launch your photographic career, you need to keep your work safe. It is likely that all your work will end up on a hard drive, whether you're working digitally or with film. The problem is that around one-third of digital camera owners make no backups of the files on their computers, so there's a good chance that one in three people reading this don't back up their computer files. Try to imagine that your computer has been stolen, or that it has been damaged by fire or water and you have lost everything on it. Don't put all your eggs in one basket. The worst part is that you can lose data without anything physical happening to your computer. Hard drives can just die on their own, and with that all of your photos are gone! I can't stress how important it is to make regular backups, and not just of your photos. Luckily, as hard drives are getting cheaper, it doesn't cost that much to get an external hard drive to back up your precious data. Once you have made your backup files it is best to keep the backup hard drive in a different building from your computer. An alternative that requires a little

less effort is to use an online backup service. Many online backup services on the Internet allow you to backup selected files and folders from your computer to the net for safekeeping. I find www.mozy.com one of the simplest to use. For a fixed monthly fee you can back up as much data as you want. For the more technically advanced there is Amazon's S3 service, which is harder to use but pay as you go, so you pay only for the amount you back up and store each month. If you haven't got much it can, without exaggeration, be just cents a month, so you can't not afford to do it.

Check your EXIF

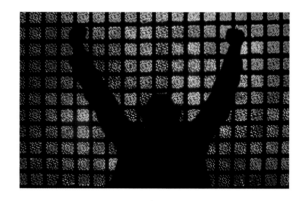

Although I took this shot some years ago, I can tell that it was shot on 1600 ISO with a shutter speed of 1/4000 sec, and the aperture set to f/4.5. You may be wondering how I know this. Do I write down the camera settings, or do I just have a good memory? Well, the answer to both these questions is no. I have trouble with my handwriting—sometimes I can't even read it back—and my memory is not the best in the world. No, the answer is EXIF. Every modern digital camera will record something called EXIF data along with the picture. The EXIF data contains information about the camera it was shot on, the date and time it was taken, and all the settings the camera was on. You can view this information on the camera itself and, in most image-editing applications, once you have the file on your computer. If you don't know where to find it, just search for EXIF in your image-editing program's Help menu.

The beauty of EXIF data is that if you are unsure how you achieved something in a shot, you can check it to see what the camera was set to. And its benefits

don't end there. When people upload their photos to Flickr (and other online photo-sharing sites such as deviantart.com and ipernity.com), they can allow other people to view the EXIF data, so if you see a digital photo on Flickr and wonder how it was taken, just click on "More properties" under the title "Additional Information" in the right-hand column and you will be shown all the EXIF data on that shot. (On ipernity.com click "View EXIF properties of this photo" in the right-hand column; on deviantart.com the EXIF data is displayed below the photo under "Details.")

Index